THE ART OF CALLIGRAPHY

A Practical Guide

On any day when he was to use his brush,
he would always have a bright window,
a clean table, fine brushes and
marvellous ink; he would wash his hands
and rinse his inkstone, as if to receive
an important guest, so that his spirit
was calm and his ideas settled;
only then would he start.

DESCRIPTION OF KUO HSI'S ATTITUDE TO PAINTING
BY HIS SON. ELEVENTH CENTURY.

THE ART OF CALLIGRAPHY

A Practical Guide

MARIE ANGEL

ROBERT HALE · LONDON

Robert Hale Limited
Clerkenwell House
Clerkenwell Green
London EC1R 0HT

Printed in Great Britain by
St Edmundsbury Press Limited,
Bury St Edmunds, Suffolk
Bound at WBC Bookbinders Limited

For Dorothy Mahoney

FROM WHOM I AND MANY OTHERS

HAVE LEARNED SO MUCH

ACKNOWLEDGMENTS

I would like to thank all those who with their
encouragement and advice have helped me to write this
book and all those who have lent me their work for
reproduction. I am most grateful to you all:
Heather Child, the Follett Publishing Company,
Richard Harrison, Ida Henstock, Donald Jackson,
Dorothy Mahoney, Sir Theodore McEvoy, Judith Mieger,
George Newman, Charles and Elizabeth Pizzey,
Roger Powell, Patricia Topping, Prue Wallis-Myers,
and Irene Wellington.

CONTENTS

1. Tools & Materials

Unlike many crafts, calligraphy can be learned at the beginning with very few inexpensive items such as pen and paper and ink. But it makes the task easier to have some, if not all, of the tools and materials listed in this chapter.

To begin with, one should have a desk or strong table situated as close as possible to a good source of light, which should fall from the left if it comes from the side. A skylight is ideal for top light. If the desk or table has one or two drawers, so much the better. All materials such as inks, colors, pens, and paper can be stored there and the surface of the desk kept clear for writing and the paraphernalia essential to the task in hand.

Unless one has invested in a drawing desk that already has an adjustable sloping surface, the next need is a good writing desk. This can be made by hinging an Imperial drawing board,

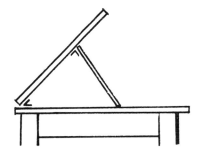

Fig. 1. *Imperial drawing board hinged to table top and supported by strut.*

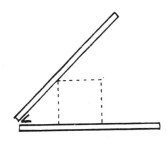

Fig. 2. *Two boards hinged together. Adjust height by books or wooden block placed behind the top board.*

1

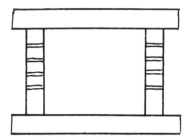

Fig. 3. Frame before attaching board.

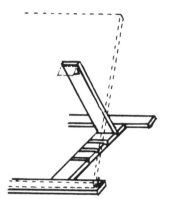

Fig. 4. Board hinged to frame and supported by struts. Height of board may be varied by using different slots.

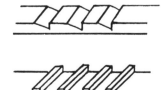

Fig. 5. To hold struts slots may be cut into frame, or small pieces of wood may be pinned or glued to the frame.

to the table top itself, or by hinging two boards together, or one board to a frame. The latter two methods give a portable writing desk, which can be an advantage, as the table or desk surface can then be used for other purposes. If nothing else is possible, write on a board resting on the lap and against a table. But this method does not give quite as good control over one's writing.

For comfort and for writing control, boards should slope at an angle of forty-five degrees to the desk surface. This may be effected by placing some support behind the board. Wooden batons hinged from the back of the board and fitting into grooves on the frame make an adjustable board. Never write on a flat surface.

On the board is pinned a writing pad consisting of several sheets of white blotting paper or several sheets of newspaper with a top sheet of blotting paper. Pinned tightly across the lower end of this pad is a stout piece of double paper called a guard. Across the top of the writing pad is stretched a length of cotton tape. The writing paper is slipped under the guard and tape, which hold it securely without pins, and the paper can be easily moved upward to maintain a constant writing level.

For starting practice work the paper

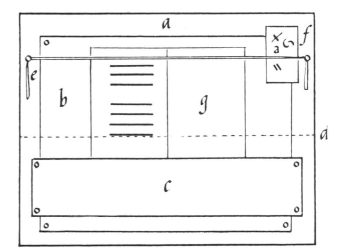

Fig. 6.
a. Board.
b. Writing pad.
c. Guard, which should be fixed just below writing level.
d. Dotted line indicates writing level.
e. Tape stretched tightly to hold head of paper.
f. Piece of paper for trying out pen.
g. Sheet of manuscript.

used may be any with a smooth, un-glazed surface and preferably white. Unruled work pads or layout pads can be helpful. When one progresses to finer finished work a good handmade paper with a smooth, fine-grained finish will enhance the writing.

A number of pencils in different grades will be required for ruling lines and margins, general rough draft work, and fine drawing and sketching. "H" graded pencils are all hard and give a fine, sharp line that will not smudge easily. "4H" or "5H" pencils are useful for ruling lines. "HB" pencils are a medium grade between "H" (hard) and "B" (soft) and are used for almost any purpose. I find that "F" grade pencils are indispensable for

drawing on paper or vellum pages, as they give a reasonably dark line without being soft enough to smudge when worked over. "B" grade pencils are soft. "4B" or "5B" are a very soft black but useful for sketching, rough drafts, and so on. For twin points to be used in practice writing, one "HB" and one colored pencil joined together by tape or twine make a good pair. Thick-leaded soft carpenters' pencils are sometimes used cut to a chisel point for practice writing.

Originally, reed and quill pens were used for all formal hands, and for some work on vellum no contemporary professional scribe would use anything else. Unfortunately, it is extremely difficult today to obtain quills that have been successfully prepared for writing.

This, added to the fact that quills need skillful cutting—an art requiring much patience and practice (and a lot of quills!)—makes it more practical, especially for beginners, to use some of the many good metal nibs available. Cards of assorted nibs suitable for round hand and italic handwriting are made by several firms and are easy to obtain. The nibs can be bought cut either square, or left or right oblique.

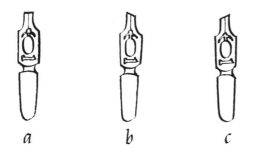

Fig. 7.
a. Straight-cut square-edged nib.
b. Right oblique-cut nib.
c. Left oblique-cut nib.

Fig. 8.
a. Interchangeable nib unit.
b. Interchangeable nib unit in fountain pen.

Very good fountain pens are now manufactured with interchangeable nib units. It is simple to unscrew one type of nib and fit in another one of different shape or width. Fountain pens ensure a smooth, uninterrupted flow of ink and obviate the necessity of filling the nib with a brush and using a reservoir. However, fountain pens do perhaps lack the really sharp edge obtained with a metal nib sharpened on a stone, and one has to decide which is the more suitable for a particular piece of work. Special very broad-nibbed pens may be bought for large lettering on posters, show cards, and notices.

A good Chinese stick ink makes the best of all inks for fine writing. The stick has to be ground down on a palette with a little distilled water. Chinese ink stones can be bought for this purpose, or a piece of glass with a ground surface will do.

For all practice work, and indeed for most work nowadays, a good commer-

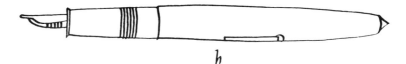

cially produced nonwaterproof ink is used. Nonwaterproof ink flows more freely than waterproof inks, which are thicker and "sticky" in consistency and tend to clog the pen. Several commercially produced inks give very good results and are easily obtainable: Pelikan (or Rotring), Stephen's Calligraph, and Winsor & Newton liquid India. All these are nonwaterproof, but it is still advisable to wash the pen at intervals to keep a crisp writing stroke. For waterproof ink, which is essential for outdoor work to combat weather conditions, FW India is recommended.

Colored inks are not as suitable for writing purposes, as the color tends to be thin and transparent. But they are useful for footnotes or marginal notes on occasion.

For all color work, watercolors in pans or tubes thinned down with water, and with a little Chinese white or process white incorporated to give solidity of color, write very well. Winsor & Newton artists' watercolors are excellent, and I have always used them myself for both writing and painting.

Poster colors and gouaches are also very useful thinned down, especially for large work, and they dry with a good mat surface. It is easier to lay a large area of color with these paints, as they will not leave a hard line if one part should dry out before another. For mixing colors china palettes divided into separate wells are ideal, but old saucers or small china jars will do instead. If color rather than black ink is to be used for the text throughout a book, the whole quantity of color thought to be necessary for the completion of the book must be mixed at one time and then kept in a small, stoppered jar so that it will not dry out; if not, it will be impossible to mix the color again to match exactly.

Several watercolor brushes will be needed: good, fine sable-hair brushes in a small size such as "0" or "00" for decorative painting and at least one in

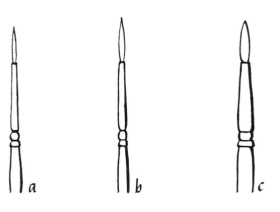

Fig. 9.
a. Fine long-haired sable watercolor brush, size "0" for color work.
b. Fine long-haired sable watercolor brush, size "1" for color work.
c. Larger brush suitable for use with ink.

a slightly larger size—"1" or "2"—for washes or for laying grounds. Ink spoils brushes, so one or two medium-size brushes in a lesser-quality hair will do for filling pens.

A nice long ruler, preferably with a metal straightedge, is another necessity, and a T-square, dividers, and a pair of compasses will all be of use. A magnifying glass helps to ascertain the sharpness of the pen nib and to analyze the quality of individual letters. A large soft eraser, such as a gum eraser, makes a clean erasure of pencil from paper or vellum and does not affect the ink or color. There are some good plastic erasers now that have the same property. To erase ink a harder type of eraser, such as that used for typewriting errors, is effective. A very sharp knife or razor-blade edge can also be used for this purpose on vellum and some types of paper.

A few clean rags are needed, for wiping pens and cleaning palettes, and two receptacles for water, one for ink and one for color. Water for paints must be changed frequently and must never be contaminated with ink, or the brilliance and purity of the colors will be spoiled.

Pumice powder is used for preparing paper and vellum if the surface should prove too greasy to write on easily. It is a fine abrasive powder and slightly roughens the surface, so that there is a nap for the nib to write on. Gum sandarac is used if a writing surface is too porous, which causes the ink to spread after it leaves the pen. It is often used in conjunction with pumice. The pumice is used first to ensure that no greasiness is present so that the pen will grip the surface, then the sandarac to ensure that the roughened surface does not allow the ink to spread and thus spoil the sharp strokes of the pen.

2. More about Materials & Their Use

When possible it is always best to work in daylight. Work done in artificial light often looks different by daylight, particularly if color is used. It is better to complete a piece of work solely during daylight hours or entirely by artificial light. In this way at least the color is consistent. Working on the same piece during daylight and under artificial light will lead to anomalies, and a good piece of work might be easily spoiled.

With the desk in position, with the light falling from the left-hand side, and the writing desk set up at the requisite angle of approximately forty-five degrees, it is wise to consider the disposition of the materials one will be using to write or paint. For the right-handed artist all inks, colors, water jars, palettes, and so on should be placed to the left. In this way the pen held in the right hand can be filled with a brush in the left hand and the loaded brush does not travel across the written work. This helps to avoid accidents—which do occur even with the most careful scribe—and it is much easier to avoid a nasty blot than to erase it.

However, if worse comes to worse, it is often possible to remove ink blots either with the point of a very sharp knife or by using a hard eraser aided with a little pumice powder. Shake a little pumice over the blot when it is quite dry and use the eraser gently in a circular motion. Do not try to rub too fiercely, as this will almost certainly cause a hole to appear in the paper. When the stain is removed as completely as seems possible it can be smoothed down, if it is to be written over, with a bone folder or an agate burnisher. A little gum sandarac may be rubbed over it, as this will prevent the ink from spreading on the slightly roughened surface.

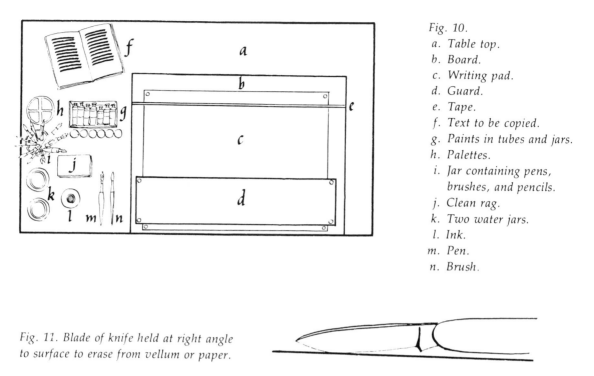

Fig. 10.
a. Table top.
b. Board.
c. Writing pad.
d. Guard.
e. Tape.
f. Text to be copied.
g. Paints in tubes and jars.
h. Palettes.
i. Jar containing pens, brushes, and pencils.
j. Clean rag.
k. Two water jars.
l. Ink.
m. Pen.
n. Brush.

Fig. 11. Blade of knife held at right angle to surface to erase from vellum or paper.

To erase with a knife, scrape the surface lightly with the blade at right angles to the paper or vellum. Even greater care is needed with a knife than with an eraser to prevent the knife from penetrating the paper and causing a hole which would irretrievably spoil the page.

If a blot is made or a brush dropped when using color it is sometimes possible—if done very quickly—to wash a great deal of the stain away. Use either an almost dry brush or a small piece of blotting paper to draw up as much of the liquid color as possible. Then, using perfectly clean water, fill a brush and drop the clean water over the stain. Leave for a moment or two and draw off in the same manner. This method may be repeated two or three times, and on a paper with a good surface the stain can virtually be removed entirely. If the stain proves stubborn, wait until the surface is again quite dry and try the pumice powder rubbed gently in with either the fingertip or a

Fig. 12. Method of filling pen with ink from brush.

piece of rag, being careful to work from the outside of the stain toward the center so as not to spread it.

Paper is undoubtedly the most widely used material for writing today and it is the best one for beginners to choose. The finest paper is handmade, but there are fewer varieties to choose from these days, since handmade paper is becoming increasingly expensive to produce.

Basically, all paper is made from various forms of cellulose material pulped in water. In handmade papers the required amount of pulp to make one sheet of paper is lifted manually from the vat in a mold of wire cloth in a frame called the deckle. When the water has partly run through the mold the operator shakes the mold to distribute the pulp evenly. The frame is then removed and the sheet of paper is pressed between felts and sized. The sheets are then passed between hot or cold rollers. Paper with a rough absorbent surface is sold as *not*—that is, *not hot-pressed.* Smooth-surfaced papers suitable for writing are sold as HP, or *hot-pressed.*

When buying paper one may be offered the choice of "wove" or "laid" papers. Wove paper is made in a wire-cloth mold and has an all-over opaqueness when held to the light. Laid paper is made on a wire-mesh mold consisting of vertical lines with slightly thicker wires laid across at regular intervals. The pulp lies more thinly over these wires, and when the paper is held to the light, the lines may be plainly seen. Watermarks are made in the same way; "handmade" or the maker's name or sign is often readable when a sheet of paper is held to the light, which is a guide to the right side of the paper. When examined closely the "wrong" side has slight indentations from the wire mold. In a book both sides of the paper are used to

write on, but for broadsides, maps, and so on the right or smoother side is chosen.

White or cream-colored papers are probably best for most purposes and approximate more nearly the color of vellum. Beware, however, of so-called parchment or vellum papers which try to simulate the color and texture of vellum but which are nearly always thick and heavy, with an unpleasant greasy surface not easy to write on and requiring much preparation.

Colored handmade or machine-made papers can be used with effect and sometimes will add impact to the text if used intelligently and with discretion. Machine-made papers are made in the same way as handmade papers but on a continuously moving belt, the paper being made in one long strip, which is rolled up finally into a large reel before being cut to the required size. It is sometimes possible to buy suitable paper for writing in rolls, and this can be useful for certain purposes such as very large posters or long banners.

Vellum is made from calfskin and, properly prepared, is the finest surface for writing and illuminating. There are two sides to vellum. The hair side is the outside of the skin from which the hair has been removed and is the nicest side to write on. The flesh side is the inner side of the skin, that nearest the body of the animal. When the skins are received from the supplier they need a lot of experienced preparation before the required velvet nap is obtained. Vellum also needs specialized binding into book form and can present many problems to the binder. If vellum is used for a book, great care must be given to the thickness of the vellum in relation to the page size, and preferably the binder should be consulted about the choice of vellum before the book is started.

Generally, very thin vellum or parchment is needed for small-paged slim books, heavier vellum for large folio-size pages. Another point to remember is that vellum is very sensitive to atmospheric conditions and in dry, hot air will curl up and become impossible to work on. Bound into book form under these conditions, the dry pages will force the covers open, and it is not possible to overcome this. Wherever the weather conditions throughout the year are likely to be hot and dry, vellum must be kept in a cool, humid atmosphere by artificial means. In England, for example, this problem hardly arises, as the weather there is normally cool and moist. Conversely, in too damp an atmosphere vellum will

wrinkle or stretch and will not return to its original size unless it has previously been stretched on a board. For this reason washes are difficult to apply when working on vellum and should be kept to a minimum.

If, having weighed the disadvantages, one still wishes to try one's hand on a nice piece of vellum, the easiest way to prepare it for writing is first to place the vellum on a well-padded flat surface—a thick pad of newspaper will do. Then rub the hair side well with finely powdered pumice, using the palm of the hand in a circular motion. If the vellum appears to have a rather greasy surface, a very fine glass paper over a wooden block can be used in the same way. The flesh side of the skin needs more care and experience, as excessive use of pumice may raise small veinings in the skin that are difficult to write over. Often it is better to rub sandarac only lightly over the flesh side. The hair side, too, should be finished with a light dusting of sandarac. It is better to use too little sandarac at first and apply more later; too much makes the surface difficult to write on, the nib dividing and leaving white marks where the ink does not flow freely onto the vellum.

After preparation any pumice or sandarac lying on the sheet should be shaken off and any surplus adhering to

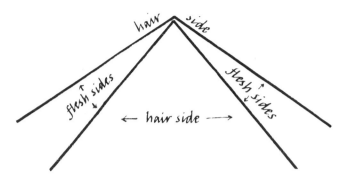

Fig. 13. Diagram showing how vellum is used in book sections.

the skin may be flicked off with a piece of silk.

The preparation of vellum is largely a matter of experience. A beginner should get some small pieces of vellum ("off-cuts" can be bought from suppliers) and experiment with these until he or she is able to judge the different types of skin and the preparation needed for his or her particular handwriting and purpose.

Erasures on vellum should always be made with a sharp knife or eraser and pumice powder. *Never* try to wash off a blot or mistake, as this will only spread and deepen the stain.

When using a piece of vellum for a broadside (a piece of writing or decorative lettering that only occupies one side of a sheet of paper or vellum) or framed panel it is customary to use the

hair side. In making up sections for a book the skins are placed hair-to-hair and flesh-to-flesh and the sheets should be arranged so that the color match is good. (Vellum comes in different shades of cream, buff, and brown, the figuration of each skin corresponding to the hair color of the animal. Each skin is unique in both texture and color.)

Before starting to use a pen, practice using pencils and double pencils (or twin points). Double pencils can be made up of either two "HB" pencils or one "HB" and one colored pencil. It is possible to use the two pencils tied together with no alteration, but this leaves the points rather far apart so that the written letter form will tend to be large. The best way of making double pencils is to shave away part of the wood from along the length of each pencil, making them as flat as possible. Then wrap the two pencils together firmly with thin twine or cellophane tape. The twin points are then closer and approximate a reasonable-size nib width.

William Mitchell steel pen nibs can be bought on cards in twelve assorted sizes with a penholder and reservoir. I use these nibs as supplied or sometimes sharpened for formal or informal work on vellum and paper.

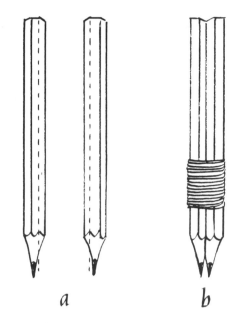

Fig. 14. Making twin points or double pencils.
a. Two pencils—dotted lines show portion of wood to be cut away.
b. Two pencils bound together after wood has been removed.

To sharpen metal pens, draw them across a fine stone, the reverse side of the nib upward, held at a slight angle to the stone. Use a little fine oil as a lubricant. Do not sharpen too finely or the edges of the chisel tip to the nib will cut into the surface of the paper instead of gliding over it.

Wash and dry all nibs carefully after use—and during use if a medium is being used that tends to clog the pen, such as waterproof ink or poster paint.

The simplest pens to use are the fountain pens with interchangeable nibs such as those made by Osmiroid and Platignum. They should never be used with waterproof ink but are excellent for all beginners for practice and for finished work using a nonwaterproof ink. They have the great advantage that the ink flows continuously so that the rhythm of the writing is not interrupted by having to stop and fill the pen nib, as is the case with ordinary metal pens.

When using a metal pen nib such as a Mitchell's, hold the pen in the right hand, then with a brush dipped in the ink held in the left hand, fill the space between the pen nib and the reservoir on the underside of the nib. The ink should not be brushed onto the top surface of the nib or this excess of ink will blur the sharpness of the writing.

A spare piece of paper should be used to try out the nib before commencing work. It is customary to write a few lines in practice before starting to write a page of a book. This gets the hand into the right rhythm and suppleness that are necessary for formal writing.

A comfortable writing position is important. The scribe should sit with shoulders and body square to the desk and forearms resting on it, with the filling brush in the left hand and the

Fig. 15. Method of sharpening nib on stone.

pen in the right. The left hand with the brush moves along just below the writing line, holding the paper down and advancing with the pen as each word is written.

To maintain the constant height of the writing line the paper is moved upward as each line is completed. The pen should be held lightly and easily between thumb and forefinger and resting against the second finger; the other fingers are curled away toward the palm and the side of the hand rests on the desk. I doubt that two people hold their pens in exactly the same manner; the important point is that it should be comfortable and convenient.

It is wrong to press heavily on the nib or double pencils. The pen, by virtue of its chisel nib, will make thick and thin strokes naturally according to the direction in which it travels and the angle at which it is held to the writing line.

I would like to mention here the many people who are left-handed but

would still like to attempt calligraphy. Left-handed writers do face problems, but they are not insoluble. Since most of us are right-handed and we have no personal experience of writing with the left hand, it is difficult for us to realize the requirements of the left-hander.

One problem has been met by the suppliers of fountain pens and metal nibs, which can now be bought with the nibs cut sharply oblique. These are the salvation of the left-hander and make writing much more comfortable for him or her.

As for the position to be used by left-handed writers, I have asked for information from some left-handed calligraphers and am grateful to them for their practical ideas, which are offered here. For italic handwriting, paper may be tilted well to the right with the bottom right-hand corner pointing toward the body. This helps to keep the writing visible and the hand away from the wet ink. The left-hander may write with the elbow well away from

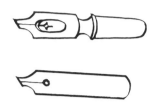

Fig. 16. Nibs cut left oblique for left-handers.

the body so that the arm has freedom of movement for writing from left to right. The pen should be held, if possible, so that the shaft points toward the left shoulder. The left-handed writer must rely on his or her arm to support the writing hand rather than the wrist and palm support used by the right-hander, and an arm movement is used when writing rather than the movement from the wrist, as with the right-hander.

It is perhaps best for the left-handed calligrapher to find the most comfortable writing position, practice diligently, and take heart, for several good scribes are left-handed.

3. Roman Capital & Lowercase Letters

Roman capital letters and the small letters derived from them are the foundation of all our alphabets used today in both written form and typeface.

Roman Capitals

Roman capital letters have distinct and characteristic proportions. The letters of the alphabet can be divided in the following way: round, wide, rectangular, and narrow letters.

The round letters are based on a circle within a square. The *O* and *Q* are perfect circles. *C*, *G*, and *D* are slightly narrower in width, but the round part of the letter has the same circular shape.

The wide letters *M* and *W* can be either the full width of the square or, as is often the case, slightly wider.

Rectangular letters are three-quarters the width of the square. These letters are *H*, *A*, *N*, *T*, *V*, *Z*, *U*. Although included in this group, *K*, *X*, and *Y* are best made a little narrower, say five-eighths of a square.

Narrow letters are half the width of the square and consist of *B*, *E*, *F*, *L*, *P*, *R*, *S*. Very narrow letters are *I* and *J*.

O and *I* are the key letters for the calligrapher. Given the proportions and characteristics of these two letters a scribe should be able to build up the other letters of the alphabet to match.

After studying the diagrams showing the skeleton forms of the Roman capital letters and their proportions, try drawing some yourself. Prepare the page by drawing double lines across your paper about half an inch apart. Leave a quarter of an inch between each set of double lines. Use a sharp pencil or a black ballpoint pen and practice the skeleton forms of the alphabet first, drawing them in their

 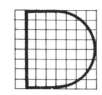 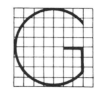 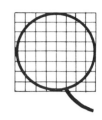

round letters based on the circle

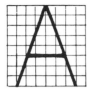

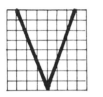

rectangular letters three quarters

of the width of the square

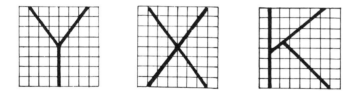

y, k and x are here grouped

as rectangular letters but may be made slightly narrower if desired

Fig. 17.

groups—round, wide, rectangular, and narrow—so that you become familiar with the characteristics of each letter.

Progress to the alphabet, observing the space between letters. These are called interspaces and should roughly approximate the space within the letter forms known as counterspaces.

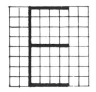

 narrow letters half the width of the square

 wide letters more than the width of the square

When you feel that you are proficient at drawing the letters, practice with words and sentences. Take care to keep to the correct proportion of the letters and learn to space the letters by eye so that counterspace, interspace, and weight of letter are evenly balanced. When you have thoroughly familiarized yourself with the skeleton forms, take your double pencils and try writing the capitals with these.

The twin points of your double pencils represent the outer edges of the square-edged nib. The width of the nib—or the width between the twin points of the double pencils—determines the height of the letter. Capital letters should be approximately seven nib widths high, so first measure off seven nib widths and space your writing lines accordingly. The space between two rows of capitals should be half the height of the letter.

Nib widths are measured across the full width of the nib by turning the pen vertically to the writing line and

ABCDEFGHI

JKLMNOPQR

STUVWXYZ

1234567890

BUTTERCUP &
DAISY CLOVER
TEASEL BUGLE
VERVAIN HOP

roman capitals in skeleton form

Fig. 18.

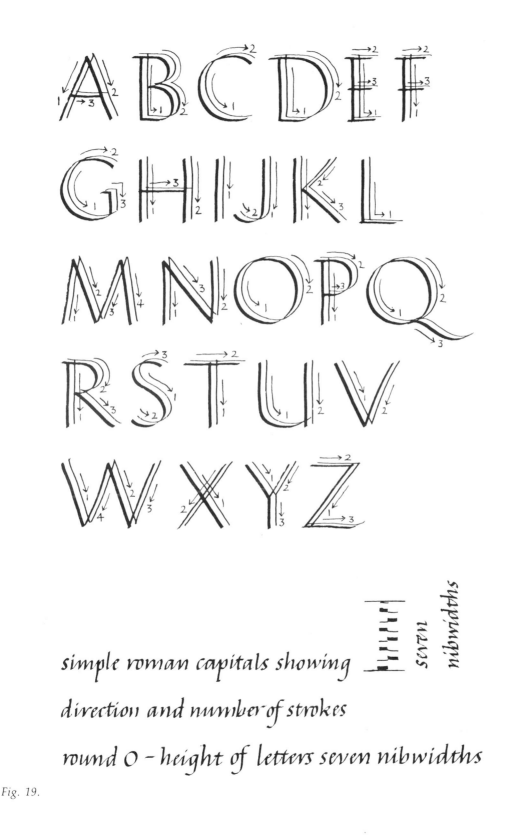

simple roman capitals showing

direction and number of strokes

round O — height of letters seven nibwidths

Fig. 19.

making short strokes in steps, each stroke in juxtaposition to the preceding one.

The double pencils should be held at an angle of thirty degrees to the writing line. As you write with double pencils the letters you have previously written only in skeleton form, you will notice at once the change in the characteristic of the letter. Your double pencils held at an angle of thirty degrees to the writing line, and with both points touching the paper, will automatically produce thick and thin strokes without any pressure being applied.

Look at the alphabet written with double pencils and note the direction and order in which the strokes are made. When making the cross strokes to *A, H, E,* and *F,* the division should be visually adjusted so that the counterspace appears to be equally divided. In *H,* for instance, the cross stroke is usually above the mathematical center. The cross strokes of *E* and *F* should all be the same length, although the lower stroke of the *E* may be made slightly longer but should not be exaggerated.

With *B, R, P,* and *K* the same rule applies. The top curve of the *B* is slightly smaller than the lower one; *R* has a slightly smaller curve at the top than *P* because of the extra space needed for *R's* tail stroke. As in *R* the top stroke of *K* meets the upright stem a fraction above center to allow for the kick of the tail stroke. *S* is based on two small circles, one on top of the other—the upper being smaller than the lower. *B* is made up in a similar fashion.

The legs of *M* may be either upright or slightly splayed. In the latter form the *M* becomes a little wider than the square. In both cases the center *V*-form should touch the writing line. *W* is usually the widest letter of all, being intrinsically two *V's* joined together.

When you use either capital or small letters, the space between words should be roughly the width of the *O.* The space between individual *letters* is determined by their shape. When two straight strokes come together the greatest space is left between them; when a curved stroke comes next to a straight stroke, slightly less space is necessary; and the least space is needed between two adjacent curved strokes.

When you can confidently write out the alphabet and space words correctly with your double pencils, commence working with the square-edged nib and black ink. Use the larger sizes of nib to start with, as it is easier to spot mistakes in the form and construction of letters in this way. The black-and-white pattern of the writing is quite different from the open texture of the writing with double pencils. The importance of the spacing of letters and of

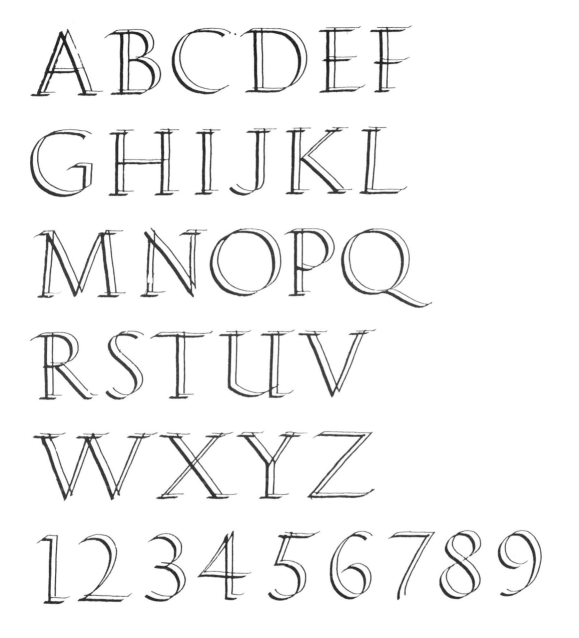

roman capitals written with twin-points to show construction

Fig. 20.

ABCDEF
GHIJKL
MNOPQ
RSTUV
WXYZ

roman capitals written with a square edged pen

1 2 3 4 5 6 7 8 9

Fig. 21

ABCDEFGHIJ

KLMNOPQR

STUVWXYZ

Roman capitals written with a square edged pen

pen angle to writing line 30°

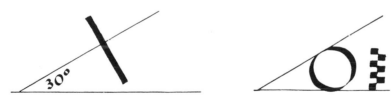

({-}) round O seven nib-widths high

1234567890 ?;!

Fig. 22.

HERON IBIS
LITTLE OWL

Counterspaces – the space enclosed within the letter forms
and interspaces – the space between the letter forms –
should roughly correspond in area.

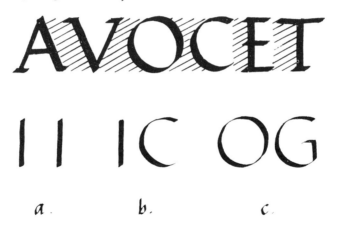

AVOCET

II IC OG

a. b. c.

a. greatest space between two straight strokes

b. slightly less space between a straight & curved stroke

c. least space between two curved strokes

Fig. 23.

the contrast between the sharp blackness of the letter form and the interspaces and counterspaces becomes immediately apparent.

Serifs are the terminal strokes of letters. With slanted pen-written Roman capitals a simple cross-topped serif is probably best. They should not be too large or exaggerated—they are finishing strokes only.

The tail of the *Q* looks more graceful if it has a slight curve. The *R* and *K* tail strokes may be either straight or curved, but if curved they should be done in such a way that the support the tail gives to the upper form of the letter is not weakened.

Small Roman Letters

Whereas Roman capital letters are written all the same height between two ruled lines, *small* Roman letters are written on one ruled line; some have ascending or descending strokes. These small Roman letters—which are also referred to as minuscules or lowercase letters—derive from the Roman capital letters written rapidly as a cursive hand.

Like the capital letters, some small letters are based on the circle and some on the rectangle. The letters *a*, *b*, *c*, *d*, *e*, *p*, and *q* are all circular in shape. The

rectangular letters are *h*, *m*, *n*, *u*, *f*, *t*, *k*, *w*, *r*, *s*, *x*, *y*, and *z*; *l*, *j*, and *i* are narrower rectangles and *g* is a letter unique in construction. Arched letters, although termed rectangular, are, where the arch is concerned, also based on the circle. The curve at the foot of *l*, *t*, and *j* and the similar curve at the head of *f* and *r* are also part of the circle, and *s* is curved at foot and head.

The way the arch springs from the upright strokes in Roman minuscules is very important. The arched stroke must start from the left-hand side of the upright stroke; as the curved stroke leaves the upright it is already beginning to thicken, so that at its junction

(marked with arrow) with the previous stroke it is firm and strong. When the curved stroke is begun at the right-hand side of the upright stroke the junction point is thin and weak.

The height of the *O* for the slanted-pen letters given is four nib widths and the *O* is circular. The space between writing lines is three *O* spaces

FOXGLOVE AND PHLOX
FOR THE BORDER, PINKS
AND VIOLAS FOR EDGING.

sentences and words written in roman capitals

ROSE SPURGE IRIS

approximately the width of an O between words

Fig. 24.

or twelve nib widths. The pen is held as before at an angle of thirty degrees to the writing line. There is an *O* space again between words.

The ascending and descending strokes of small Roman letters should be uniform, about three nib widths above or below the four nib widths of the body of the letter to which it is joined.

The letters may first be practiced without serifs; later a simply written horizontal serif may be used, but the more decorative triangular serifs add to the classical beauty of the letters, if their construction can be successfully mastered.

Study the skeleton letters of the alphabet in the same way that you did for the Roman capitals. Practice first with pencil or ballpoint; progress to double pencils and then square-edge pen as you become more proficient. It is very important to follow the direction and order of the strokes as shown in the double-pencil alphabet.

With small Roman letters, never use double writing lines in an attempt to achieve uniformity in height; this will only lead to a cramped appearance in the letters. If necessary, measure off your four nib widths and make a small mark of this height at the beginning of each line. With experience and constant practice this may soon be left out and you will find that your hand and eye will enable you to write evenly across the line.

Fig. 25.

FALCON to keep margins visually straight

GOOSE round letters and splayed letters such

RUFF as A, M and W should overlap slightly

COOT into the margin

small roman letters based

on the circle

small roman letters showing

their proportions and relationship

to circle and square

Fig. 26.

abcdefghijklmn
opqrstuvwxyz

magnolia japonica daphne
cypress juniper acer broom
mahonia viburnum berberis

1 2 3 4 5 6 7 8 9 0 & & &

alternative form of numerals and ampersand

- abbreviated form of 'and' derived from the latin 'et'

Fig. 27.

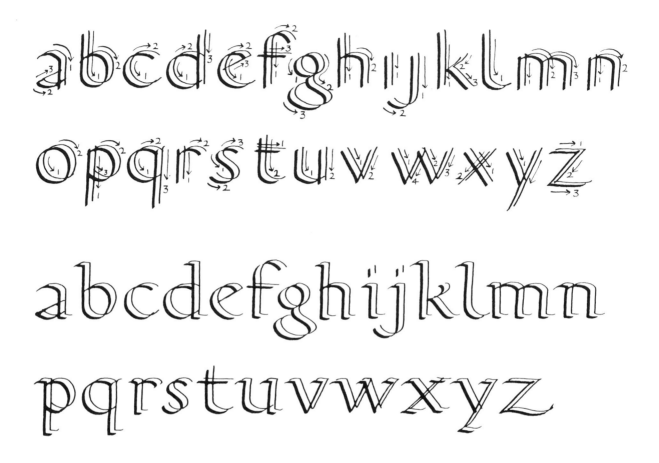

small roman alphabet written with twinpoints showing

construction direction and number of strokes.

Fig. 28.

abcdefghijklmn

opqrstuvwxyz

abcdefghijklmn

opqrstuvwxyz

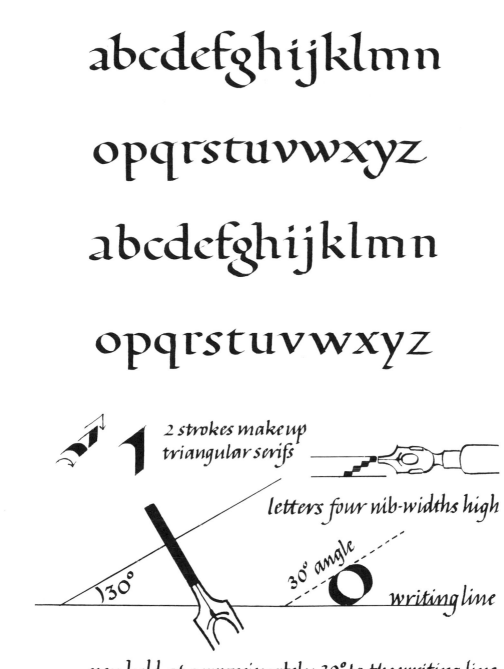

2 strokes make up
triangular serifs

letters four nib-widths high

30° angle

30°

writing line

pen held at approximately 30° to the writing line

Fig. 29.

fennel germander mint

borage rosemary thyme

marjoram parsley dill

Fig. 30.

Blessed art thou, O Lord our
God, King of the universe, who
with the scent of this lowly
herb transportest the soul.

right wrong

teal teal

smew smew

eider eider

dunlin dunlin

coot linnet

margins must be kept visually

straight by overlapping round

letters over the marginal line

Fig. 31.

Numerals are not very easy to write or group successfully, but they must be mastered, since they so often appear in pieces of work as dates and street numbers and so on. The easiest way to write them is to keep the numerals the same height as the letter *O*. However, with some groupings the alternative way of writing numbers with ascenders and descenders may produce a more pleasing appearance.

Punctuation marks, such as periods, commas, exclamation and question marks, should be kept as simple as possible and not too large.

When you start practicing sentences, incorporate the capitals you have already learned with the small letters. Keep the capitals seven nib widths high so that you will have the ascenders of the minuscules at the same height as your capital letters.

For writing words the same rules apply as those for capitals: straight strokes wide apart, a straight and a curved stroke closer together, and two adjacent curved strokes closer still. Counterspaces and interspaces should take up approximately the same area so that there should be an even texture of black and white in the finished line of writing.

Always remember that writing is meant to be read and that uniformity and evenness of texture allow the eye to run quickly along the writing line, therefore increasing legibility.

When writing pages of text, keep the left-hand margin vertical and straight in appearance. An irregular edge at the right-hand margin is permissible. To keep the left-hand margin straight, it is necessary to adjust the first letter of each line visually.

Curved and rounded letters should be written to project over the ruled marginal line. Straight-stroked letters should be started on the marginal line.

Letters with splayed legs, such as *A* and *M* in capitals and *Y, W,* and *V* as both capitals and small letters, should also be written to project into the margin.

If the first letter at the beginning of a line were written so that it touched the ruled marginal line an irregular appearance would result. This is another instance where only the eye can be used to adjust and space the letters.

4. A Formal Italic Alphabet

As the Roman small letters came from quickly written capitals, so the italic hand was derived from writing the Roman alphabet at speed. This led to the lateral compression of all the letter forms, an elongation of ascenders and descenders, a heightening of the letter in proportion to the nib width, and the sloping of the letters to the right.

In the italic alphabet, therefore, the O is no longer a circle but is oval in shape; the corresponding letters, a, b, c, d, e, p, q, are also based on the oval form. As the arched letters in the Roman formal hand are related to the circle, so in the italic hand they are to the oval. This leads to the arch branching away from the stem of the letter at a different point, about halfway up the stem, instead of branching at the shoulder of the letter as in the Roman minuscules.

Scribes have used this type of writing very effectively for less formal manuscripts and for poetry, for which the graceful form of the letters is particularly apt.

The elongated ascending and descending strokes are frequently flourished, but I would like to warn beginners that to use flourishing successfully requires a great deal of experience and manual dexterity. It is better for beginners to eschew the delights of "fancy" writing and devote themselves instead to really mastering the basic construction of the letter forms and grouping them in simple arrangements. Simplicity in writing and design is far more effective than a multiplicity of hands decorated with unrelated curlicues assembled together on the same page. This approach to writing is often beloved by the amateur and the results cause many a shudder

35

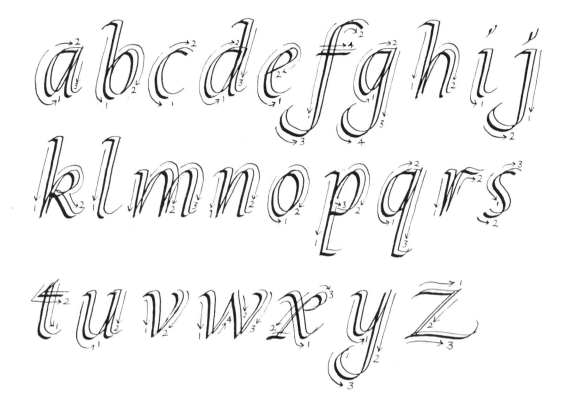

formal italic alphabet written with twin-points showing construction and number and direction of strokes.

Fig. 32. Twin-point alphabet showing construction, number, and direction of strokes.

when viewed by professional scribes. It cannot be emphasized too strongly that a sound knowledge of the construction of each alphabet and a straightforward arrangement of the letters when used either in a manuscript or in any other form should be the aim of the beginner.

Go through the routine for learning the formal italic hand as you did for the foundational Roman alphabet, using progressively double pencils and then a square-edged pen and ink.

Notice the difference in shape of some of the letters—a, g, and f, for instance—and also look carefully at the direction and number of strokes, the order in which they are made, and the slope to the right of this alphabet.

You will notice that to make the italic letters the pen is used differently. Instead of the pen strokes being pulled as in the previous alphabet the pen is now pushed to make some of the letter forms. For a the first stroke is made by the pen being drawn down and then pushed up—all in one movement without the pen being lifted from the surface of the paper. Similarly, with b the second stroke is made by pushing upward from the stem of the letter and then down to join the first stroke.

This pushing of the pen is a prime characteristic of the italic hand. So look really carefully at the alphabet, giving the direction and order of the strokes, and practice the pushing movement of the pen by writing a whole line of u's and m's, which will also help to get your hand into the different rhythm needed for italic writing.

When using a formal italic hand, keep each letter separate from the next as far as possible, although some natural linkage is almost bound to occur. In a cursive italic or "running" hand, all the letters can be joined, except where the ligature would be awkward.

The lines for the formal italic alphabet should be ruled farther apart than for the Roman alphabet. The space between writing lines depends on the length of ascending and descending strokes.

The height of the O is six nib widths, so the minimum space between writing lines would be eighteen nib widths, and probably more than this would be needed to avoid entanglement of ascenders and descenders.

The angle of the pen to the writing line may be kept at thirty degrees as in the previous alphabet, but a higher angle up to approximately thirty-five degrees is common with an italic hand.

The simple serif is made by pushing the pen upward before beginning the down stroke—or the top of the stem may be hooked or curved.

The long descenders of f, g, and y

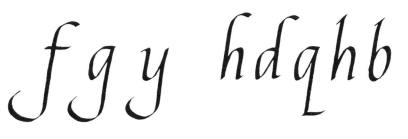

alphabet based on oval O
arched letters branch about halfway up the stem

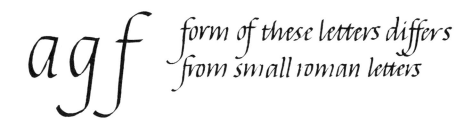

alternative stroke endings for ascenders
and descenders

a g f form of these letters differs
from small roman letters

height of O six nibwidths

Fig. 33. Construction of letters from oval O—alternative ascenders and descenders, O height approximately six nib widths.

ABCDEFGHIJKLMN
OPQRSTUVWXYZ

abcdefghijklmn

opqrstuvwxyz

goldfinch serin crossbill
nightingale robin siskin

formal italic in skeleton form

Fig. 34. Skeleton alphabets and words.

have distinctive tail-endings. They should be carefully made and attention given to their shape, weight, and direction so that the letter form is well balanced as a whole unit.

Capital letters are also compressed laterally and slope gently to the right. They are made in a similar fashion to the Roman capitals already practiced, but a little more freely. Remember to adjust the proportions of the letters to the oval *O* form.

In some ancient manuscripts, however, upright Roman capitals are used with the italic hand and have a very dignified appearance when proportion and weight are correctly adjusted. Capitals with italics should generally not be too large and are usually lower in height than the ascenders of the lowercase letters.

Traditionally, italic capital letters are those most often flourished. No examples are given in this book, as it is

abcdefghijklmn

opqrstuvwxyz

formal italic minuscules

Fig. 35. Alphabet written with square-edged pen.

A B C D E F G

H I J K L M

N O P Q R S T

U V W X Y Z

formal italic capitals

Fig. 36. Alphabet of formal italic capital letters.

Not from yesterday or the day before do these things live, but from everlasting, and no one knows from whence they took their beginning.

Fig. 37. Piece of prose in formal italic with Roman initial capital.

for beginners, but many examples can be found in old manuscripts and contemporary works, and there are reproductions in most books on calligraphy. But it is best to remember that a simple Roman-type capital, well written and constructionally sound, will always look better than a badly flourished capital that the student has not fully understood.

THE CUCKOO SONG

The cuckoo is a merry bird,
She sings as she flies;
She brings us good tidings,
And tells us no lies.
She sippeth sweet flowers
To keep her voice clear,
That she may sing CUCKOO!
Three months in the year.

Fig. 38. Cuckoo song.

5. Handwriting

It is very difficult to take a real interest in calligraphy without being influenced by the beautiful form of the letters one is studying to such an extent that the natural reaction is a resolve to improve one's handwriting.

A hand suitable for everyday use should be easy to write with freely made letters requiring few pen lifts while remaining legible. Such a hand is the cursive or running italic.

Cursive italic minuscules are similar to the formal italic in the basic form of the letters, but written faster, and the letters are joined to each other by ligatures, both horizontal and diagonal; thus many whole words can be written without having to lift the pen from the paper. However, these ligatures should not be forced; and it will be found that some letters when they come next to each other are best left separated. Tailed letters, such as *j, y, g, f, p,* and *q,* are not joined diagonally to the fol-

lowing letter although they may be joined by a horizontal ligature to the previous letter. The minuscule *r* is another letter that often remains more legible if it is not joined to the following letter. Note that the diagonal ligature is a thin, straight line, which contrasts sufficiently with the curved strokes of the minuscules *m, n,* and *u* to keep them legible.

Capitals used with cursive handwriting should be kept small and simply written. Again they may be based either on the oval *O* or on the upright classical Roman capitals, according to one's inclinations.

Cursive writing adds distinction to correspondence. When writing letters, you should give a little thought to the margins and the general layout of the page, but lines and margins should not be ruled and an informal approach is desirable. Cursive handwriting can also be usefully employed for marginal

notes or footnotes in books and for unlimited purposes in everyday life, such as handwritten invitation cards, place names and notes on small maps, menus, and so on. Even a shopping list looks nicer written out well in easily readable handwriting.

One might think that the use of the italic cursive as a basis for handwriting would lead to a general uniformity in calligraphers' handwriting, but this is not the case. Initially, one may stick rather rigidly to the pattern alphabet, but familiarity with the letter forms, the speed necessary in everyday use, and one's own preference for certain characteristics of form soon lead to a very individual style instantly recognizable by friends and associates.

ABCDEFGHIJKLM

NOPQRSTUVWXYZ

abcdefghijklmnopqrstuvwxyz

Fig. 39. Alphabet of capitals and small letters in cursive italic written with a square-edged pen.

mnmnmnm ununun aumynudmcan

au nu mn mp an ah do uk fo fi fe

tt ss ll œ op oq uy ug og rg wo we

hawthorn cedar elm alder maple box

hornbeam sycamore alder chestnut

ash oak yew lime beech birch aspen elm

Fig. 40. Some examples of ligatures and words written in cursive italic.

He that planteth a tree is the servant

of GOD. He provideth a kindness for

many generations and faces that he

hath not seen shall bless him.

Fig. 41. Piece of prose in cursive italic hand.

Dear Mavie, many thanks for sending me so many excellent prints from which to select for CALLIGRAPHY TODAY. I have retained the 6 I think will reproduce well + out of these I hope to put 3 or 4 in the book. I am returning the others, it was difficult to make a choice.

The ones I have retained are:
1. John Dow - Beasts in Heraldry
2. Con Howe - personal initials
3 Rosmarinus
4 Rosa Eglanteria
5 + 6 M + V from Two by Two.
 Love from Heather
 21. 3. 75

Fig. 42. Heather Child, M.B.E., Member of the Society of Scribes and Illuminators and well-known writer of books on calligraphy and heraldry.

28 May 1976

Dear Marie :

In my letter to you the other
day in mentioning the catalogue
that Lou Strick is coming back
in two or three months to do,
there was mention of Lou planned
to use about six of your drawings-
those with calligraphy - but he
also asked if he might include one
of your letters. Shd you be willing
I'm sure you would like to see
what might be considered for
inclusion. Lou has only seen one
of the air mail letters & asked
if I had any that would reproduce
better. I believe there are some in
black on white but I have to 'dig
them up'. Or, perhaps, when you
are finished with your present
project you may be so kind as to
send something.

All the best,
Richard

Fig. 43. Richard Harrison, Lay Member of S.S.I., who writes a straightforward italic script.

 SOCIETY FOR Calligraphy

February 11, 1976

Dear Miss Angel,

Around the holidays I received the newsletter from Judith Meiger which mentioned your interest in information about calligraphy societies, etc., to be published in a forthcoming book. During that busy season I mislaid the newsletter and just recently located it. By now you may have sufficient information on our society from some other source, but if not I will include some in this letter. The Xerox is a copy of a "rough" done for another publication but states our purpose and a brief "early history." Prospective members may get in touch with me at the address below, or our Secretary-Treasurer, 1817 Selby St. #8, Los Angeles, Ca. 90025.

In our next Newsletter we will be publishing a list of classes in this area. If you wish, I will see that you receive a copy in early March.

If you will excuse a personal note, I have much admired your beautiful work which I first saw in "Modern Lettering and Calligraphy" and "Calligraphy Today" — purchased several years ago.

Sincerely,

Patricia Topping

Patricia Topping, Chairman / 4915 Hartwick Street, Los Angeles, California 90041 (213) 256-4256

Fig. 44. Patricia Topping, who writes a more ornate italic script than the former example.

Dear Marie Angel,

Thank you for your letter of June 1st about advice for left handers in connection with the book you are writing. I don't know whether the reference to left handers in the enclosed notes are of any use in this situation, but I am enclosing them – (such as they are) – just in case they will help. If you are needing much more detail than this, I would have to get down to it when work is not so hectic as it is

Fig. 45. Prue Wallis-Myers, Member of the Society for Italic Handwriting, a left-handed writer whose interest in teaching italic handwriting in schools and whose experience in left-handed writing was of immense help to me while working on this book.

at present. But please let me know
and if there is anything else I
can describe or try to show I
shall be very happy to help
where I can.

you may be interested to see the
difference between my right hand
movements and my left hand ones.
this is done with my right hand
where the 'flow' from one letter to
another is much easier because the
wrist comes into play to help.
The left hander does not have the
wrist support and so can not join letters
so easily — at least this is what I
find.

10 June 1976

Dear Marie,

We were so glad to hear from you again and to know that you are surviving the drought and flourishing the Flymo. I too have an electric Flymo 47 and find it just the thing for our rough and steeply-sloping patches of what used, for a few brief months, to be grass. Our soil is mostly blue clay and builders' rubbish and is either a bog or a brick according to the weather. As you can imagine, it is mostly brick now but, in spite of the drought, there is still a big patch too wet to tread upon. You never know where water will spring up or dry up, which complicates planning but is a characteristic feature of the strange geology of these parts.

However, when a perennial has decided to live here, nothing stops it and flowers that didn't appear at all last year are now blooming madly, including some

Fig. 46. *Air Chief Marshal Sir Theodore McEvoy, K.C.B., C.B.E., Member of the Society for Italic Handwriting and Lay Member of the S.S.I. A very free and natural adaptation of italic handwriting to personal use.*

Fig. 47.
Irene Wellington, Member of S.S.I., whose characteristic handwriting is always a joy to receive.

Fig. 48.
Ida Henstock, M.V.O., Member of S.S.I., who has an interesting calligraphic hand that is not entirely based on italic but is extremely decorative and expressive of the writer's personality.

The White House North End
near Henley - on - Thames
(Oxon)
POST

29 - August 1969

Dear Marie.
I have been asked by some one where your two Bestiaries can be obtained. He wants to get them for a friend I said I we ask you.
A lovely morning here a hint of an autumnal feeling
I am "snowed under" & appalled as to how I shall ever get this clear. Some furniture to go to sale room in London next week. (I shd

LANDSCAPE WITH RIVER AND CATTLE
John Sell Cotman (1782–1842)
Given by J. E. Taylor, Esq.

Water-colour. 8⅞ in. by 12⅞ in.

P.29 Victoria and Albert Museum 93—1894

Hope all your CATS thrive

So the cats now have an extra room to play in, or will have. I think the growing of tomatoes is an excuse, but — a nice one! Your friend in Bath seems to have gone a little further. with play-room for her six cats!! (& easy chairs!!) By the way, what do you feed your Siamese on? My friend's "Holly" will only eat rabbit — 90p. each here! And she sometimes has 3 in a week!

Roger Powell
HON MA DUBLIN

The Slade Froxfield Petersfield Hampshire
Tel Hawkley 073084 229

10th September 1974

Dear Marie,

How sweet of you to write! We had a lovely party with as many of the family as were able to come & lots of neighbours. Every one seems to have enjoyed themselves, besides the "principals"!

Rather too much commissioned work is behindhand; mainly collectors items wh. only I can deal with but there is one girl coming along well and another joining, at any rate part time. Also a pupil who after getting a Ph.D at Oxford is determined to set up in his home county — Norfolk — as a book repairer & conservator.

Our best wishes for all
your doings

always Roger & Rita

Fig. 49. Roger Powell, O.B.E.—*another very decorative and characteristic hand.*

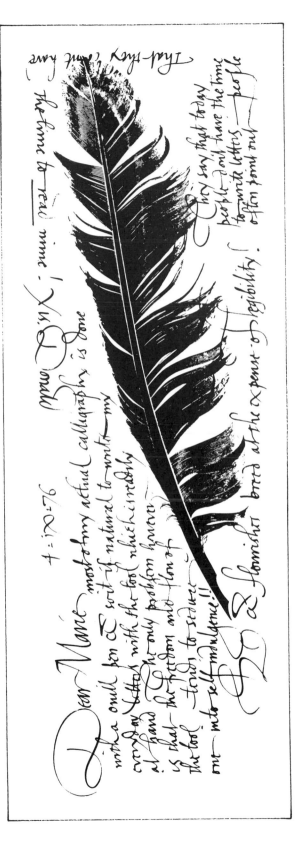

Fig. 50. Donald Jackson, Member of S.S.I.—
written out with great freedom with a quill,
especially for this book.

Dorothy Mahoney A.R.C.A.
Calligrapher
Oak Cottage, Wrotham, near Sevenoaks, Kent
BOROUGH GREEN 2406

27 September 76

My dear Marie,

What a task to set me on a Monday morning!

I rather agree with Stanley Morison who in a letter addressed to a Mr. Reynolds in 1932 wrote 'To my mind handwriting must be 'Natural' because it must be fast. I like to see an obviously speedy piece of script. I hate a letter which exhales the scent of some calligraphic cosmetic. Give me a true cursive, let it run as fast as one can make it and at the same time keep it sufficiently regular. If keeping the pen on an uninterrupted line helps let us by all means make it a rule to write so; but it is my experience that it is a_ restful and b_ an assistance to speed to run on or to take off at will — that will which operates automatically as the result of experience.'

Chors to be done, washing & ironing, heaps of apples asking to be bottled but they won't be because I want to work on my book.

Love Dorothy.

P.S. a VERY poor example. the paper is more porous on the right. hand side than it is on the left. ~

Fig. 51. Dorothy Mahoney, Member of S.S.I.—a letter, written especially for this book, whose contents are a valuable guide to all who wish to acquire an italic hand of their own.

6. Planning a Book of One Section

To make a small book is a very good exercise when one is learning to write. Apart from the sense of achievement when the work is accomplished, a great deal can be learned on the way.

The first thing to decide upon is the text of the book. Choose something that is not too long, as enthusiasm can wane and a short, finished book is better than a long one that never gets beyond loose sheets of paper.

Poetry is more difficult than prose to arrange on the page, especially if the lines are of very unequal length. So choose the text carefully and then decide which hand is the most appropriate to the sense and feeling of this choice—a Roman hand for a serious piece of prose or a formal italic for a set of verses or lighter prose.

Choosing the paper is the next step. This will have a bearing on the size of the book, as paper can be bought in different-size sheets. When making a manuscript book it is economical to use a size into which a sheet of paper may be folded.

A sheet of paper folded once is called a *folio;* folded twice to form four leaves it becomes a *quarto* (4to); folded three times it becomes an *octavo,* or eight leaves (8vo).

To fold paper, place the corners of the paper together, level up the edges, and smooth the sheet with the flat of the hand toward the fold, making sure that the edges remain level. The fold may then be cut with a sharp knife. Paper can also be cut with a knife and T-square if sharp, clean edges are de-

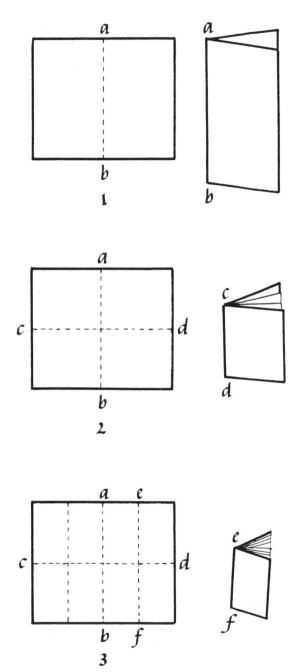

Fig. 52.

1. *Fold sheet of paper once for folio-size page—
a–b becomes center fold.*
2. *Folding sheet of paper for quarto-size pages.
First fold a–b, then fold c–d; c–d becomes center
fold of pages.*
3. *Folding sheet of paper for octavo-size pages.
First fold a–b, second fold c–d, third fold e–f; e–f
becomes center fold of pages.*

sired or if a piece of paper is required of a size not available by folding. Remember that a large folio-size page will need a stronger paper than a small octavo page.

A T-square should be used to square up pages before ruling them for writing.

When practicing handwriting it is enough simply to rule lines across the width of the page, leaving perhaps a small margin on either side for neatness. When contemplating a book page greater care must be taken to ensure that the proportions of the margins are correct and pleasing in appearance. Margins frame the text and focus the eye on it.

Traditionally, the proportions of the margins are as follows: the margin at the foot of the page is twice that at the head of the page, and the side margins are less than the foot margin but a little larger than the head.

Since two pages are seen together when a book is opened (this is com-

monly called a "double-page spread"), the inner margin of a single page is half that of the outer margin. This can be seen clearly in the diagram. These proportions for margins—1½, 2, 3, 4—are only a guide and may be altered to suit any particular book or personal preference. I am rather fond of a generous foot margin. An important point to be remembered is that margins have a practical value in preserving the text from handling when the book is in use.

There are several ways of mathematically determining the proportions of text and margins to the page area. I prefer to judge mine by eye, using a little guesswork. Bearing in mind the proportions previously given, it is not too difficult to arrange the writing lines for a piece of prose. One or two rough drafts will generally furnish one with a size of writing to produce eight to ten words to the line, and the line spacing can then be worked out from the height of the O. If a method is preferred, the simplest one that works for a folio or octavo page is to take the width of a single page as the height of the text column and two-fifths the height of the page for the width of the writing line. Arrange this area on the page so as to obtain the correct proportion of margins.

If a book is to be bound, remember

Fig. 53. Double-page spread showing the proportions of margins.

to leave slightly larger margins all around, as the stitching of the book takes a little off the inner margins and the cutting of the book after it is bound removes a little of the side, head, and foot margins.

Once the margins have been determined, the number of text lines must be decided. There should be eight to ten words to the line. The size of writing that will give approximately this number of words to the line can be found by experimenting with different widths of pen. Once the height of the O has been established the line may be spaced out to accommodate the hand the scribe intends to use. Any extra space can be added to the foot margin.

Lines should be ruled lightly with a very hard pencil. Normally, the side margins are ruled in first and the hori-

zontal writing lines afterward. The top and bottom lines of the text column are often ruled right across the page. Marginal and writing lines in a book should not be erased after the writing has been completed; these lines are part of the book.

When ruling pages for a book it is quite a time-saving idea to make a ruling guide from the same paper as that used for the book. Cut a piece of paper about one and a half inches wide and a little longer than the total width of the double-page spread. Rule a line down

the average number

the average number of

the average number of words to a line is

|——|

4½ inches

Fig. 54. Trials to find the average number of words to a line—for example, one of four and a half inches in length. Four nib widths height of O— three O-spaces between writing lines.

the center of the strip or fold it in half along its length. On one side mark the measurements for the foot and head margins and the text lines, and on the other side mark the measurements across the double-page spread for the side and inner margins. It is essential that these measurements be very accurately made. This strip can then be laid on each page and the measurements marked off. It saves time and remains reasonably accurate if used with care.

A vellum strip may be made in the same way, but it must be kept with and under the same conditions as the vellum pages. If this is not done the vellum strip may shrink or stretch more than the pages—because of different atmospheric conditions—and this will throw out the measurements of the book.

Some scribes prefer to rule carefully the first pages, which are then laid exactly on top of the next and pricked through at the junction of the lines with a sharp-pointed device, such as a needle. It is possible to prick through an entire section in one operation by this method, but it is essential that all the pages be accurately aligned. Remember that continuous pricking through the same set of holes can widen them and lead to errors in the ruling.

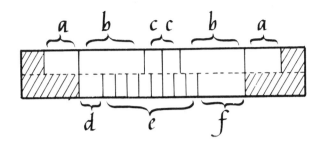

Fig. 55. Ruling guide made from strip of paper.
a. Width of side margins.
b. Width of text columns.
c. Width of inner margins.
d. Height of head margins.
e. Height of text column and number of writing lines.
f. Height of foot margin.

Fig. 56. Double-page spread marked up for ruling or pricking through.

Double lines the height of the letters should be used for written capitals but only single lines are necessary for minuscules. It is a good idea to check measurements occasionally whichever method of ruling is used. Otherwise you may find the last pages of the book different from the first.

Plenty of time and thought should be given to the preparation of the page and the proportions and weight of text to the margins. The final ruling of the lines is the architectural plan on which your book will be built.

Verses are more tricky to arrange than prose, since the length of line

FOR HE IS OF THE TRIBE OF TIGER.

For the Cherub Cat is a term of the Angel Tiger.

For he has the subtlety and hissing of a serpent,

which in goodness he suppresses.

For he will not do destruction, if he is well-fed,

neither will he spit without provocation.

For he purrs in thankfulness, when God tells

him he's a good Cat.

Fig. 57. Method of dealing with very long and short lines in a piece of verse.

may vary considerably and it may be necessary to fit an exact number of lines to a page. For beginners, the easiest way to write out poetry is to begin all lines at the left-hand margin as with prose. For more experienced scribes the pattern of lines of a particular set of verses might call for an arrangement with some lines inset or all lines arranged symmetrically from the center of the page. Care should be taken with this sort of design, because too many indentations in the text column are disturbing to the eye. Remember, legibility is the scribe's first aim.

On the whole, preference should be given to a straightforward presentation, with the left-hand margin as the starting point for all lines. If it is found that a very long line will not fit into the text column the words left over may be written on the following line, inserting this second line of writing about half an inch in from the left-hand margin. This looks better than one very long line protruding from the text column.

With prose writing, too, if only a few words remain before the beginning of a new paragraph or chapter and these few words—if one continued—would be on the first line of a new page, it is better to add a line at the foot of the previous page.

When planning a single-section book, remember that only a limited number of leaves can be bound in this way, depending on the thickness of the paper or vellum used. No more than eight to ten thin paper leaves or four to six thin vellum leaves should be used; otherwise the book will not open well after it has been bound.

If you are contemplating a folio-size book, take eight sheets of the chosen paper and fold them once down the center of the greatest width of the sheet. These eight folded sheets are then placed one inside the other to make a section of sixteen leaves or thirty-two pages.

Four pages at the beginning and four pages at the end of the section are left blank as endpapers when binding the book. The remaining twenty-four pages will make up the writing area of the book.

It is customary to have a title page for a book. This should be placed on the first inside right-hand, or *recto*, page. The following recto page will be the opening page of the book. So there is a blank page before the title page and a blank page before the opening page of text. If an illustration is desired opposite the opening page this should not be on the reverse side of the title page. Two pages should be left blank after the title page, with the illustration appearing on the next left-hand, or *verso*, page, opposite the first text

page. For a small, single-section book it is not often necessary to have a list of contents; but if included it should come between the title page and the text—again on the recto page.

The title page should have the title of the work and the author's name, and the design should have a definite link with the arrangements of the text pages. The area of the text column can be used as a guide, the margins being the same as in the body of the book. If large capitals are used for the title page the whole space may be filled, but usually such details as title, author's name, and so on are symmetrically arranged, conforming where possible with the text area of the book.

Decoration is often used on a title page, either as simple color in the lettering, a small decorative design or emblem, or a patterned border.

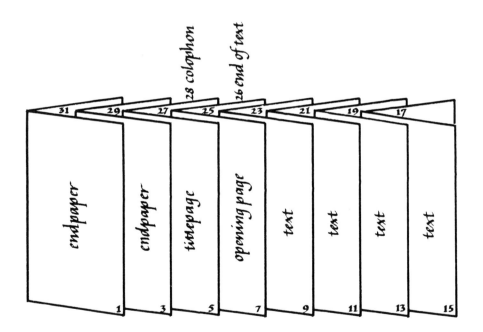

Fig. 58. Single section composed of eight folio sheets of paper showing arrangement of endpapers, title page, opening page, text, and colophon.

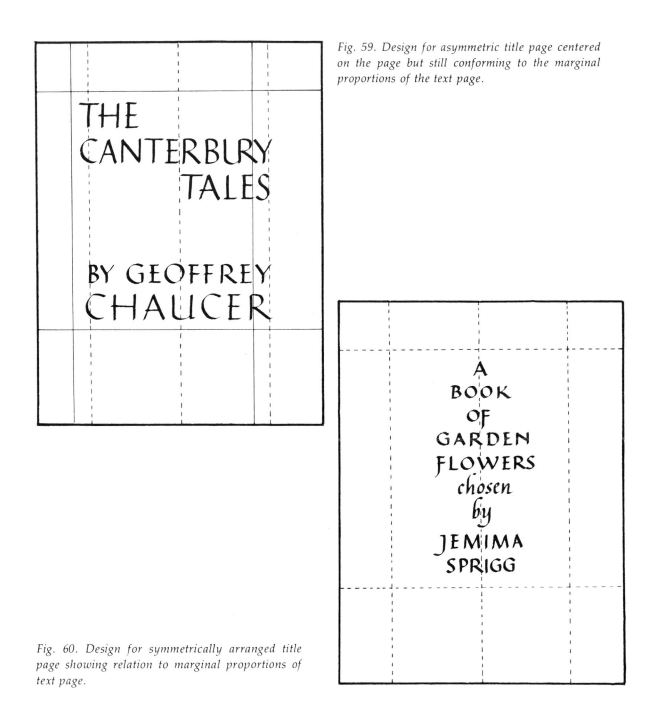

THE CANTERBURY TALES

BY GEOFFREY CHAUCER

Fig. 59. Design for asymmetric title page centered on the page but still conforming to the marginal proportions of the text page.

A BOOK OF GARDEN FLOWERS chosen by JEMIMA SPRIGG

Fig. 60. Design for symmetrically arranged title page showing relation to marginal proportions of text page.

I DO NOT WANT I CHANGE;

I want the same old and loved
things, the same wild flowers,
the same trees, and soft ash-green;
the turtle doves, the blackbirds,
the coloured yellow-hammer,
sing, sing, singing so long as
there is light to cast a shadow on
the dial, for such is the measure
of his song, and I want them in
the same place.

Fig. 61. Design for opening page of small book.

The opening page of a book is most important. However simply a book is planned, a large initial letter two or three line spaces high, and the first two or three lines written in simple capitals, make a good beginning. If possible, the whole initial sentence should be written in capitals and they should preferably be kept in a block— that is, with the final letters of each line terminating at the same point on the writing line. This defines the text column. One or more colors may be used in the opening, and the large initial is ideal for incorporating a decorative design. It is not necessary to keep rigidly within the text column when writing the main body of the text.

REJOICE in the LORD O ye
righteous: for praise is comely
for the upright.
PRAISE the LORD with harp:
sing unto him with the psaltery
and an instrument of ten strings.
SING unto him a new song: play
skilfully with a loud noise.

Fig. 62. Beginning of psalm marked with initial letter placed in outer margin—verses marked by first word being written in capitals.

I VALUE my garden more
for being full of blackbirds
than cherries, and very frankly
give them fruit for their songs.

Fig. 63. Paragraph marked by large initial capital set within the text column.

SINCE THE WEATHER OF A DISTRICT
is undoubtedly part of its natural history
I shall make no further apologies for the four
following letters which will contain many
particulars concerning some of the great frosts,
and a few respecting some very hot summers
that have distinguished themselves from the
rest during the course of my observations.

Fig. 64. Paragraph marked by first line written in capitals.

Words should not be broken erratically; it is better either to intrude into the inner margin—or outer, as the case may be—or to leave a gap and begin the whole word on the next line.

Paragraphs may be marked by a large initial letter placed in the outer margin or partially set within the text. The first word or first line may be written in capitals and may be in a different color from the text.

A certain uniformity should be kept throughout the book. Do not have one paragraph with an initial in the margin and the next with one inset—this is distracting. The same is true with color. Too many changes of color are disturbing, prevent the eye from concentrating on the text, and break up the page, giving it a bitty appearance. To begin with, it is probably better to write in black and one other color. Red, blue, and green are traditional second colors.

The main part of the text is written first and the capitals in color are written afterward. The amount of space required for the capitals may be judged by eye or roughed out with pencil. For a complicated opening page the lines of capitals may be worked out on a piece of tracing paper so that enough line space is left. It is better not to draw the capitals directly onto the book page and then try to write over

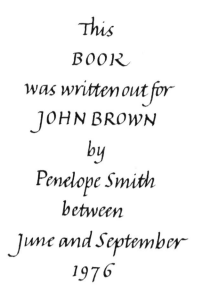

Fig. 65. A colophon arranged symmetrically and giving some details about the book.

Fig. 66. Simple colophon of initials of scribe and date.

them, since this usually results in cramped-looking letters. It should always be one's aim to write letters freely without any previous preparation.

At the end of the book it is customary to write or design a small colophon, or emblem, which gives the name of the writer and the date on which the book was completed. It can also give such details as for whom the book was written or why it was written or any information the scribe wishes to include. The simplest colophon is one's initials and the date—for example, M.A. 1977. For a more informative colophon one might use the following formula: "This book was written out for (so and so) by (one's own name) between (such and such a date)."

Some craftsmen design a special mark with which to sign their work, which makes it instantly recognizable. They may use a monogram or cipher of their own initials, a design suggesting their craft, or a reflection of some personal preference. The colophon belongs to the scribe; anything that he or she wishes to be known about the book can be put into it.

Fig. 67. Monogram colophon and date.

7. Practical Use of Calligraphy

Once one has learned the basic alphabets, it is pleasant to be able to use them in a variety of ways, some of which are suggested here.

Anyone who lives in a small town or village will be able to help out with advertising club shows, public meetings, church events, and so on by designing and writing out handbills and posters for the events.

Another use for fine writing is to make personal greetings and invitation cards and to design bookplates or monograms and ciphers for oneself or friends.

A keen gardener may like to keep a handwritten record or notebook relating information of planting dates, plans and data for the future positions of plants and bulbs, and so on. Anyone with a talent for drawing might illustrate the book here and there wherever a particular favorite—or perhaps rare—plant is mentioned. The same type of book may be made on any subject in which the scribe is interested. Quite simple arrangements of text and headings are best for this sort of record, since the book might be written over a number of years.

Catalogs, too, may be written out by hand and added to as the collection grows—of books, music, antiques, or whatever. These catalogs can be of real use as well as being good to look at. Some very beautiful catalogs were written in italic handwriting in the sixteenth century. Their simple but

dignified and uniform arrangement showed a restraint and understanding of the craft, and they are an example to all who practice the italic hand. If one cannot attempt a drawing, photographs may be used instead in catalogs and records. An account of one's travels or a particularly interesting holiday might be treated in this way.

An illustrated map of a journey—your own town or area, or a place of interest visited on a vacation—is another decorative way of using one's skill as a writer.

When working on a broadside or poster for display out of doors, make sure that the paper is fairly thick if it is to be pinned up. Thinner paper will do if the poster is to be pasted on boards. The other essential requirement is that the medium used be waterproof.

Before designing the layout of the poster read the message it is to convey and note other details that are to be incorporated.

Posters do not have as large margins as book pages. The side and top margins may be equal but there should

Fig. 68. Scribes Workshop—display notice by Donald Jackson.

FLOS IN PICTURA NON EST FLOS, IMMO FIGURA; QUI PINGIT FLOREM NON PINGIT FLORIS ODOREM.

LINES FROM SUSCIPE FLOS FLOREM, MS. BENEDICTBEUERN

Fig. 69. Design for broadside.

be a greater space left at the foot of the sheet.

Posters may be arranged either with all the lettering starting from the left-hand margin or symmetrically with the letters evenly spaced from a central line. Other asymmetrical arrangements can be made, and the scope for design-ing such posters rests with the capabil-ities of the individual scribe.

Two or three sizes of writing may be used. The largest-size nib is used for the major information, which might also be in red or some other eye-catching color. Keep the lettering bold and simple and preferably use color only for the most important details, let-tering the remainder in black. Too many different colors or types of letter-ing on one poster confuse rather than inform.

Nowadays broadsides are frequently

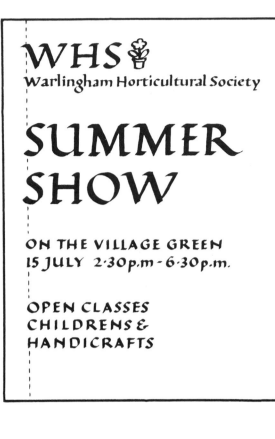

WHS 🌼
Warlingham Horticultural Society

SUMMER
SHOW

ON THE VILLAGE GREEN
15 JULY 2·30p.m - 6·30p.m.

OPEN CLASSES
CHILDRENS &
HANDICRAFTS

Fig. 70. Asymmetrical design for poster—all lines starting from the left-hand margin.

Fig. 71. Symmetrical poster design—lines of writing being arranged from central dotted line.

WARLINGHAM SCOUTS

GRAND
JUMBLE
SALE

20 OCTOBER
at the Church Hall

PROCEEDS TOWARDS THE
NEW SCOUT HUT

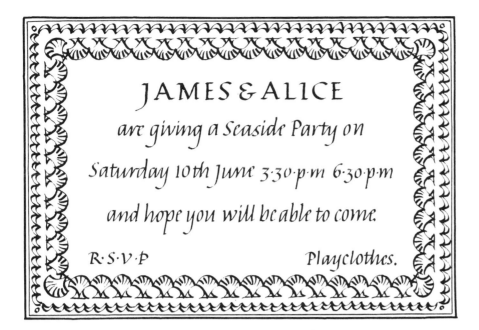

JAMES & ALICE

are giving a Seaside Party on

Saturday 10th June 3.30 p.m 6.30 p.m

and hope you will be able to come.

R·S·V·P Playclothes.

Fig. 72. Invitation card with decorative border.

Fig. 73. Invitation card by Sheila Waters, A.R.C.A., Craft Member of the Society of Scribes and Illuminators who has now made her home in the U.S.A. and holds workshops and classes for advanced students.

We hope you will be able to come to an
informal cocktail party
on the occasion of
Roger Powell's 70th Birthday
in the Senior Common Room at the
Royal College of Art. Kensington Gore
on Tuesday 17th May at 6.30 pm

R S V P
Peter Waters Cedar House Froxfield Petersfield Hampshire

purely decorative in form and are usually framed and used as wall decorations. Margins are usually smaller in proportion than those used in books but are variable. The side margins are normally of the same width. Broadsides may be used for fairly long pieces of prose or verse or may consist of only a quotation or even a single word

treated in a decorative manner. In the same way a broadside may be quite small or very large, according to its purpose.

Rolls of honor, memorial inscriptions, and records of those who have held some particular office in a university or in public life may all be designed as broadsides. They have one advantage over books in that they may be displayed easily in public places and are protected by glass and frame.

When designing greeting cards or invitations, first decide on the size that will fit a standard-size envelope if the card is to be sent through the mail. If the design is to be reproduced by line block the work should be done in opaque black ink. For invitations, re-

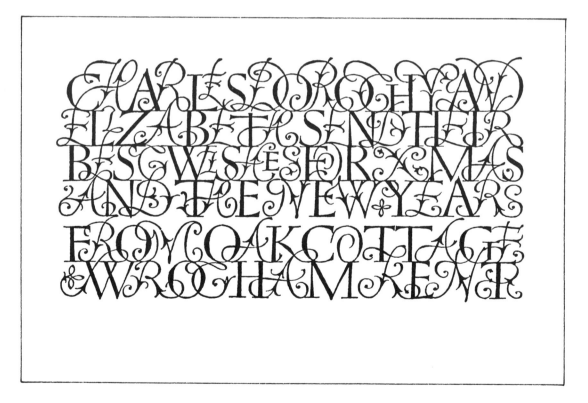

Fig. 74. Personal Christmas card designed and written by Dorothy Mahoney.

member that the message must be made plain and the date, time, and place be clearly stated.

One or more colors may be used. A personal cipher or monogram, or, for an association or organization, a trademark may be included in the design.

Like a broadside or poster, invitation cards may have the lettering arranged symmetrically or asymmetrically, but whichever method is used make sure that all the essential data is legible and prominent. For Christmas, birthday, or other greeting cards more decorative methods may be tried.

The extremely decorative card designed by Dorothy Mahoney is not perhaps easily legible, but deciphering the message from the lighthearted treatment of scrolls and flourishes reminiscent of wrought-iron work was part of the enjoyment for the lucky recipients. This type of card needs a great deal of skill and pen control and a sound understanding of the underlying letter forms, but the other piece of writing by the same scribe, showing the interior of a card, proves how effective a simply written and well-spaced message can be.

Another very decorative arrangement is shown in Irene Wellington's design for the fiftieth anniversary of the Society of Scribes and Illuminators. This is flourishing at its best, echoing

Fig. 75. Interior of Christmas card written by Dorothy Mahoney.

the festivity of the celebrations. The more serious design, made up of beautifully written capitals linked and conjoined in a pattern that never obscures the message, is well worth studying.

The apparent ease with which these two professional scribes appear to play

Fig. 76. Design from folder commemorating the fif-tieth anniversary of the Society of Scribes and Illu-minators, written by Irene Wellington.

most printers will charge very little extra to provide cards in several different colors with the design overprinted in black.

When a drawing is used with writing for a greeting card a balance must be achieved between drawing and lettering, or one must decide which will take precedence. The type of lettering should be appropriate to the drawing. A delicate pen drawing might be swamped by an overlarge Roman letter, whereas a light italic will enhance and show off the drawing.

Another idea for sending greetings to friends on anniversaries is to use the initials of their names in a decorative pattern or in conjunction with drawings or pieces of writing on their favorite pastimes or interests. For such ideas interlaced letters or monograms may be used, and for design purposes the proportions of the letters may be altered, provided that this does not distort the letter or make it entirely illegible.

Circular letters may be looped together, or straight-stemmed letters may have a common stem. Tails of letters may be drawn out to accommodate a stem for another letter, or letters may be reversed. Letters may be written inside others or written so close together that they touch and form a linked pattern.

with letters is not easily achieved but is brought about by many years of dedicated work and experience. Lesser mortals will be content to use simple interlaced capitals or a little pen drawing, or just rely on well-written letters for their cards.

Colored paper can be a very effective and decorative background for greeting cards. If a card is to be reproduced

It is important, when designing ciphers and monograms, that the letters, while forming a pattern, still be readable. Care should be taken with junction points. It is not normally a good idea to have the horizontal bars of letters running into one another, and if used with drawings or decorations, junction points should not be obscured if the legibility of the letters would be affected.

Initials of surnames should take precedence over Christian names. For instance, take the initials B.H.—H being the surname initial. The obvious way to link the letters would be to use the right-hand stem of the H as common to

MERRY CHRISTMAS

Fig. 77. *Personal Christmas card designed by Marie Angel.*

Fig. 78. *Personal Christmas card designed by Marie Angel.*

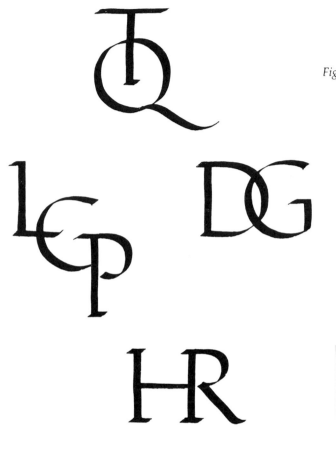

Fig. 79. Interlaced letters and monograms.

EX LIBRIS

Fig. 80. Design for bookplate showing how monogram can be used.

both letters with the B written the right way around. However, this might give the impression that B is the surname initial. Therefore it would be better to reverse the B onto the left-hand stem of the H—the reversed letter immediately becoming less dominant than the H and the letters also being in the right order of precedence.

Any decoration or drawing within the letters should be carefully spaced, and if a naturalistic style of drawing is used subjects should not look contorted. Birds, for instance, may perch on crossbars or at the head of upright strokes. Animals can move through circular shapes and be interlaced with the letters, but their natural stance and movement should be retained if it is at all possible. Heraldic beasts come into a different category, and here the stylized heraldic poses should be kept. Floral decorations are perhaps the easiest to manage, as plants can be curved or bent to fit most spaces. But even so, growing points should be adhered to, and a good study of the plant concerned should be undertaken before attempting to turn it into a design.

Purely decorative designs made up of pen strokes and used as a diaper pattern (a pattern of repeated, small figures) either within the letters or as a background may be attempted by anyone. Cleverly used color can be of im-

Fig. 81. Decorative initial by Marie Angel (from Two by Two by Toby Talbot, published by the Follett Publishing Company).

mense help in making this type of design more interesting. Borders around cards can be easily made with the pen, and soon each scribe will have his or her own favorite pattern. The choice is practically infinite, depending on the ingenuity of each calligrapher.

Color is possibly the greatest aid to legibility. With interlaced letters even a different shade of the same color will be of assistance in separating letters from each other.

Colors in calligraphy used to be almost entirely reserved to the red, blue,

Fig. 82. Some diaper and border patterns made with simple pen strokes.

and green shades associated with heraldry, and with gold, silver, and black, except in the painting of miniatures, which is rather beyond the scope of this book. Anyone interested in this subject can find some books on it in the local library. The *Book of Kells* is a wonderful example of interlacing at its zenith, and beautiful illuminations in various styles occur throughout the ages.

Recently, colors have tended to be used more subtly by scribes, and the use of softer reds and browns, greens, grays, blues, and so on, are often seen in headings and for the written text. Vermilion mixed with black has always been an acknowledged way of making a good brown color for writing.

Decorative treatment of letters and the use of drawings and patterns calls for a certain amount of layout and rough draft work in pencil first. For interlaced and monogram letters it is advisable to work out the problem first with skeleton forms before the letters are written out.

Record books should be kept simple, as they may be added to over the years. But a good beginning can be made with a title page and a large heading on the first page, stating the intention of the book. For a garden record the statements following could

Fig. 83. Decorative initial with diaper pattern.

perhaps consist of the plant's name in small capitals and the relevant details either in small Roman or small italics or a combination of both. Small Roman would be used for the details of the plant itself and small italics for notes on its subsequent progress. A few lines could be left blank between each subject so that further notes can be added over the years, if desired. Color can be used for the names of groups of plants or for any data system that the student may invent.

This sort of treatment is suitable for all records. The more ambitious might wish to illustrate the records, and the arrangement of the pages then becomes an individual exercise according to the ability of the scribe.

Catalogs follow the same treatment and should be kept to the necessary information neatly written with capitals and small letters well balanced. The

PRIMULA VIALII (syn. P. littoniana)

Unusual spire-like spikes of lilac flowers topped with crimson buds.

Needs cool position. Plant in plenty of leafmould or peat. Not often longlived so keep seed and raise new plants annually to replenish stocks.

Fig. 84. Example of layout for garden record book.

Fig. 85. Example of catalog layout.

VICTORIAN SAMPLERS.

1. Small sampler. 14 x 10 inches. Not in original frame.

Worked in fine coloured wools on linen with alphabets and text in red and birds, flowers and houses in various colours.
Signed Mary Hall and dated 1872. (my paternal grandmother)
Aquired through the family.

2. Large sampler. 17 x 26 inches. In original frame of birds eye maple.

Worked in various coloured wools on canvas with several alphabets, religious text, and decorative border.
Signed Elizabeth Spier 1873. (my maternal grandmother)
Acquired through the family.

name of the subject should be more prominent so that the eye reads it first, with the notes taking secondary place, to be read if required. Again, small drawings and diagrams may be inserted and cross-reference systems be color-linked.

For decorative maps a lot of rough drafts and working drawings are needed and much research into the area concerned if the map is large and complicated. For beginners it is suggested that a small map be tried first. Those interested can move on to more intricate themes as they become more proficient.

People who live in out-of-the-way places often have to give directions to

Fig. 86. Small decorative map.

friends and visitors on how to reach them. A little map can be of immense help here.

Clear writing of place names and numbering of roads is essential, and small, labeled drawings of landmarks to watch for are valuable and can make a charming introduction to one's home and surroundings. Start off by tracing the roads you think necessary for the route and mark the way to your house with arrows. Other information can then be added, but do not make too many drawings or the map might confuse your visitors. Keep it all simple and your guests will arrive at the right time.

These maps may be printed on the back of your invitation cards or incorporated in the design.

This chapter has explored just a few of the ways you may use your writing with enjoyment. There are many other ways that keen calligraphers will find for themselves.

8. The Layout & Decoration of Manuscript Books

The simplest form of decoration in a book is the mass and texture of the minuscules correlated with distinctive capitals, with the whole balanced proportionally to the page area and the margins.

The contrast of size and weight in initial letters, headings, and text and the delicate balance between these areas and the marginal spaces are of the greatest importance when designing a layout for a book.

A basic pattern on an important page such as an opening page of a book will consist of a large initial capital two or three lines high written with a very broad nib, the heading to the depth of the initial capital written also in capitals but using a narrower nib, and the rest of the page in minuscules written either with the same nib width as that used for the small capitals, or a narrower width still, depending on the length of the writing line; bear in mind the need to average eight to ten words to the line. It is sometimes easier to think of this sort of pattern tonally, the large capital being the deepest tone, the smaller capitals medium tone, and the minuscules the lightest.

PRAISE YE THE LORD.

PRAISE ye the Lord from the heavens: praise him in the heights.

PRAISE ye him all his angels: praise ye him, all his hosts.

PRAISE ye him, sun and moon: praise him, all ye stars of light.

PRAISE him, ye heavens of heavens, and ye waters that be above the heavens.

LET them praise the name of the Lord: for he commanded, and they were created.

Fig. 87. Design for opening page—beginning of Psalm 148.

Quis color illi vadis, seras cum propulit umbras

Hesperus et viridi perfudit monte Mosellam!

tota natant crispis iuga motibus et tremit absens

pampinus et vitreis vindemia turgit in undis.

Quis color illi vadis seras cum propulit umbras

Hesperus et viridi perfudit monte Mosellam!

tota natant crispis iuga motibus et tremit absens

pampinus et vitreis vindemia turget in undis.

*Fig. 88. Examples of how greater space between writing lines alters
the pattern effect of the writing on the page.*

The amount of space given to the heading and initial capital is important too. A heading that occupies exactly half of the text column leaving the other half of its depth for the minuscules will give a top-heavy appearance to the page. About a third of heading to two-thirds of text would be better proportions.

Adjustments to line spaces can also affect the appearance of a page. A compressed hand written on lines wider apart than is necessary will give a heavier ribbon pattern to the page. With an italic hand, when the lines have to be spaced farther apart to accommodate the elongated ascenders and descenders, these strokes themselves form

oh oh oh *a*

variations in weight achieved by using different width nibs for letters of the same height

os OS OS *b*

weight variations obtained by using the same nibwidth for letters of four. six, and eight nibwidths high.

Fig. 89.
a. Variations in weight by using different-width nibs for letters of the same height.
b. Variations in weight by using the same nib to write letters of different height.

a pattern within the line spaces contrasting with the more solid mass of the writing line. With lines written closer together the writing takes on an overall pattern and the ribbonlike quality of the writing line is not as apparent.

Students should carefully consider all these points before designing a manuscript book and study the effects of varying the weight and size of letter by writing with different-size nibs and also by writing different heights of letter with the same-size nib.

Compressed letters based on the oval O and written with a fairly broad nib give a much heavier appearance on the page than if written with a narrow nib.

anemone nemorosa

anemone nemorosa

anemone nemorosa

anemone nemorosa

anemone nemorosa

Fig. 90. Example of the same words written with the same nib in small Roman and formal italic at varying heights, showing difference in pattern and weight.

The same effect can be achieved by writing letters based on the round *O* with broad and narrow nibs.

With four nib widths as the ideal height for the foundational Roman hand, one achieves a well-balanced, even texture from upright and rounded strokes and the counterspaces and interspaces. Using the same nib width and lowering the *O* height to three nib widths, the counterspaces are immediately decreased in area with a corresponding decrease in the interspaces, which results in the ribbon of the writing line appearing darker and heavier on the page. If the *O* height is raised to five or six nib widths and the same nib is used, the counterspaces and interspaces are increased, which, with the lightening of the strokes, gives a lighter and more open pattern to the page.

Not only do the weight and texture of the lettering concern the scribe but also the weight and substance of the text itself. One must always strive to achieve a sympathetic relationship between the author's work and the transmission of that work onto paper through the medium of the scribe's calligraphy.

Design of pages becomes more complicated with the introduction of color. Red, normally vermilion when used in calligraphy, is the standard color for brightening manuscripts. It is used for initial-letter openings and paragraph headings, marginal markings, numerals, marginal notes and footnotes, and other decorative patterns. Blue is the other color most generally used, with green following. When you use color in manuscripts, it is desirable to keep an even sprinkling of the chosen colors throughout the book. One small capital in the same color will serve to emphasize and balance a larger capital or heading on the opposite page.

Undoubtedly, colors can be of help in interpreting the mood of the text.

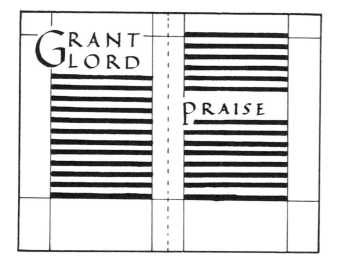

Fig. 91. Large paragraph heading balanced by smaller heading on opposite page.

One piece of writing may suggest a cool approach using greens, grays, and blues, whereas another piece might best be rendered in warmer tones.

Until fairly recently red, blue, green, white, black, and gold were predominant in book design, but many contemporary calligraphers are now experimenting with more subtle variations in color schemes in the same way that they experiment with the shape and form of letters and the design of the page as a whole. There are infinite ways in which letters and color can be used decoratively in calligraphy. Each scribe must decide whether to opt for traditional colors and design or a more contemporary approach.

Simple patterns made with the same pen as that used for the written text were a natural step in book decoration. These designs are made by using the pen in straight, curved, or zigzag movements similar to those used in the formation of letters. Large initial letters may have their counterspaces filled with a small pen-made diaper pattern, or the letter itself may be enlivened with a motif.

Borders may be made up in a similar way, using a variety of strokes, to make a useful finish to maps and broadsides. Color is important in these patterns, and its judicious use will enhance them considerably. Red, blue,

and green are commonly used but any suitable color may be used to enrich the work.

Drawings of plants, animals, birds, and other subjects should be made with a square-edged pen, which may be of smaller nib width than that used for the text. The pen can be used at any angle as a drawing instrument. Being square-edged, it will, of course, continue to give thick and thin strokes that may be used with effect in the drawings. Fluid and rhythmic drawings with a lively and sensitive line appear in early manuscripts and should be looked for either at museums or as

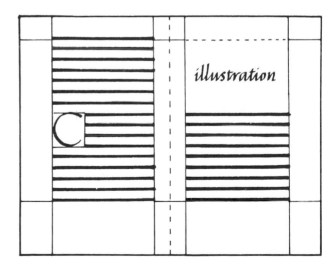

Fig. 92. Large capital in lower verso page balanced by illustration on recto page.

Fig. 93. *Entire recto page given over to illustration within marginal limits.*

Fig. 94. *Evenly balanced pages with a greater area of space above the halfway point left for the illustrations.*

reproductions in books at local libraries. These drawings were often the preparatory outlines for miniature paintings, and the same technique of pen outline to be filled in later with color is still practiced by many scribes.

When designing a book that is to include drawings, leave not only spaces for any large capitals, page headings, or paragraph headings, to be filled in after the main body of the text has been written, but also spaces within the text at the places to be illustrated by the drawing. Decide first whether the drawing is to be incorporated with a large initial letter or whether it is to stand alone. Read the text and mark the passages to be illustrated. Do not keep to a rigid plan throughout the book, with every drawing appearing in the same position on the chosen pages. Rather write the text, leaving spaces where appropriate. Some judgment is needed, however, in arranging the spaces proportionally on the pages. A whole page may be given over to a drawing with a facing page of text, but remember that the drawing should not exceed the area of the text column and the margins surrounding it should remain substantially the same.

Be careful not to place drawings too low on the page, with perhaps only one or two lines of minuscules below the drawing. This gives an unbalanced look to the page, unless it is very clev-

erly counterbalanced by some other drawing or initial on the opposite page. A band of decoration or drawing across the foot of the page, if it is in harmony with the text, can look very pleasing and keeps the text well up in the page. Borders may run around the whole page, with decorative illuminations formal, semiformal, or frankly realistic in character.

The student must learn how to judge by eye the placing of decoration or drawing on the page so that the right balance is maintained among margins, text column, and decoration. Common sense should prevail. Because it is traditional to start an opening page or a new chapter with a large initial letter and preferably the whole of the first sentence in smaller capitals, it does not follow that if the page should have fifteen lines and the first sentence takes up fourteen of them the last line should be written in minuscules. Far better in such a case to turn the whole page into a design made up of capitals of the first sentence and continue with the text in minuscules on the following page.

The type of drawing or miniature to be attempted must also be kept in mind when planning a book. Will the drawing be of the same weight and texture as the lettering—as may be the case if the drawing is made with the same pen as that used for the writing—

Fig. 95. Uneven areas of space balanced by placement on page.

Fig. 96. Double-page spread with borders.

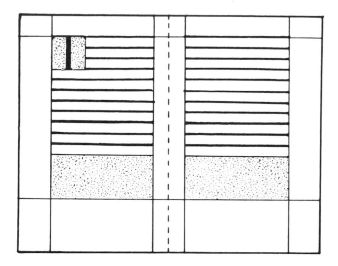

Fig. 97. Double-page spread with large decorated capital and foot borders.

drawing. The stronger text will act as a frame for the paler-toned space, and to have it too low in the page would weaken the page structure.

Sometimes in ancient manuscripts beautiful miniature paintings, highly decorated capitals, and borders take up as much as two-thirds or more of the page area and are the dominant feature. When this is so, one expects to find the writing of the text fairly heavy in weight to maintain the balance between writing and painting. This sort of illumination would seem rather derivative if attempted today, and contemporary calligraphers convey in a different, if less-disciplined, way an equal richness of color and design.

The entire first word of a heading or page opening can be made into a design. The large initial letter holds the remaining letters within it or adjoining it, the whole making a pattern enriched with color or further decoration, if desired.

To keep within the given space for the heading and the lines of uniform length, the capitals may be linked or share an upright common stem in the same way as a monogram. A number of calligraphers now join capitals at the head and foot as well as laterally to form a pattern from the letters themselves.

Calligraphers have been "playing"

so that there will be little difference in visual pattern between the two, and the page incorporating the drawing will have much the same weight in comparison with a page made up entirely of lettering? If so, make the drawing in some other color than the text to give it prominence.

Conversely, the drawing or painting may be much lighter in weight than the text surrounding it and greater care will be needed in placing these light areas on the page. When possible, the bulk of the drawing space should be above the halfway mark of the page, with more lines of text below than above it, especially with a lighter-tone

high mountains or in the the great forests its nest is built in hollow trees and

Fig. 98. Pen drawing related to writing—the drawing is made with the same nib as that used for the writing.

OUR
DEBT
IS
LARGELY
TO
EDWARD
JOHN-
STON

ALSO
TO
W.R.
LETHABY

WHO
HAD
THE
PER-
CEPTION
TO
SENSE
JOHN-
STON'S
LATENT
GENIUS

with letters since the advent of writing, as a study of historic manuscripts will show, but each age has its own individual way of doing so.

Painting in manuscript books can be carried out in several ways. Pen outlines for decorations consisting of small flowers and leaves, and so on, may be filled in with spots of color; and the painting, while enriching the drawing, is secondary in importance to the firm outlines left by the pen. In larger drawings with pen outlines, or for decorative initial letters, the outlines may be filled in with flat color with further color added over the first coat if required; or the areas to be colored are filled in with small strokes of the brush or by stippling. Washes are not easy to apply on either paper or vellum, which wrinkle unless they have first been stretched.

Brushes used for mixing paint and for loading pens may be of medium size and cheap hair, but brushes used for fine painting should be of small size with long sable-hair points.

Fig. 99. An interesting design of joined capitals made by Irene Wellington for the folder commemorating the fiftieth anniversary of the Scribes and Illuminators.

Numbers "0" or "00" Winsor & Newton Series 3A have longer hair than some small brushes and retain the paint better without drying out too quickly, but these brushes are not always easy to obtain. One or two larger sizes of the same-quality hair for laying grounds or washes are also required.

Good gouaches in tubes are to be had in brilliant colors, are easily thinned with water, and mix well together. They also dry flat, which is a great advantage if used for writing or for large patches of color. They store well in quantity if kept in a small airtight jar. The more expensive gouache colors have a soft brilliance which has a pleasing quality. The cheaper gouaches, although quite suitable for student work, are less subtle in texture and color.

Watercolors in pans and tubes are suitable for color work on any type of manuscript. The colors are pure and transparent when used for fine minia-

Fig. 100. Freely written decorative capitals by Donald Jackson.
Note also the attractive pen drawing of the crown.

Fig. 101. The potential of the brush. All the textures and brush marks shown here are made with the same brush (size "1"). A brush has a minimal thin stroke and a maximum thick stroke like that of a square-edged pen, but it is infinitely more flexible than a pen, and the variations between the thinnest and thickest stroke are not automatic as with the square-edged pen but are achieved by pressure on the brush. It is a much more versatile instrument than the pen or quill.

ture painting or other painted decoration on vellum or paper. This is important if one uses either hatching or stippling on miniatures, because the first color laid shows through the succeeding layers as one builds up the painting, giving a very delicate appearance when completed.

If an opaque finish is desired, the color may be mixed with a little Chinese white. I always use process white for small white areas, such as spots and minute details, like highlights in eyes or stamens, and so on. This is because it is essential that tiny details be brushed in only once; to retouch will nearly always spoil the crispness of the stroke and enlarge the detail. Process white, if used at the right consistency, will dry white over other colors; Chinese white will not do this with such certainty. Process white is also very useful for any work done for reproduction, as it will mask mistakes so that they will not show up in the photographs necessary for reproduction purposes.

Some beginners have little idea of which colors to choose for their palette. The colors in the following list comprise my entire stock, of which only a dozen are in everyday use. (The colors used are Winsor & Newton artists' watercolors in tubes.) These colors are quite sufficient for my work and brilliant, rich effects can be obtained by judiciously mixing them:

> Yellow Ochre
> Cadmium Yellow Pale
> Cadmium Lemon
> Cadmium Yellow Mid
> Naples Yellow *
> Cadmium Orange
> Rose Madder *
> Scarlet Lake *
> Vermilion
> Chinese White *
> Cadmium Scarlet *
> Indian Red
> Purple Lake *
> Winsor Violet *
> Ultramarine
> Cobalt Blue
> Prussian Blue
> Cerulean Blue
> Viridian *
> Process White

My methods of working are as follows. With large-scale work I block out the design first with a brush and watercolor. I use washes for areas such as leaves or large animals, but this has to be done very quickly and efficiently to prevent the vellum from wrinkling and is not a recommended practice for beginners. Over these washes a fine

* Used only occasionally

brush is used to build up the drawing in other colors.

With small miniatures the entire work is built up of tiny hair strokes and stipplings. Several colors are laid one upon another, but because of the transparency of the watercolor and the hatching of the strokes, the first color used will still be apparent in the finished work. It is important to remember that the first color will affect the second, and so on, each layer of color changing the ones already laid on the surface.

It is difficult to lay down hard and fast rules about the mixing of colors. Students should experiment for themselves, as this is the only real way to learn what various combinations of colors will produce.

I find Indian red a most useful color. It can be combined with practically all the colors. With any of the blues it makes a very good gray of varying density and tone according to the blue used. In almost equal parts with Prussian blue it makes the only black I use. (Ivory black is a dead color and lacks the intensity of a mixed black.) With cerulean blue a soft green-gray is achieved and with cobalt blue, a pigeon-gray. Indian red can also be used to dull or gray a too-brilliant green.

Greens I make from combinations of any of the blues and yellows or orange.

Cerulean and orange make a soft green.

Orange I find very useful for greens tending to olive. Added to gray it inclines that color to green or it enlivens browns.

Indian red darkened with Prussian blue is used as a basis for many browns. They may be lightened by a touch of yellow or orange and warmed by a little vermilion or scarlet.

Of the reds vermilion comes first and is a great standby. Rose Madder or Scarlet Lake may be used for pinker tones.

Viridian is rather thin as a tube color and is not often used, but its unique color makes it invaluable for some purposes. It may be mixed with a touch of Chinese white to give it body. Mixed with a cadmium lemon it gives a very intense light green sometimes seen at the center of a flower.

Of the blues my preference is for cobalt, other blues being of less all-around use. Ultramarine I use the least and certainly never on its own. Mixed with other blues or with Rose Madder it is useful for mauve tints and purples. Cobalt mixed with a little Ultramarine and a tiny touch of Prussian blue makes a good solid blue for capitals or backgrounds. A little white added to blues gives them more weight, but it must be only a touch or the true color will be spoiled. Prussian

blue is also a very dominant color and I never use it on its own. But it is a great help in strengthening other blues or for darkening other colors. It will kill other blues, so it must be added very carefully to any blue mixture. The same goes for mixing it with yellows or orange to form greens—it is very good for these purposes but extra care is needed in assessing the right amount to be added.

When using red, blue, and green in the traditional way in manuscript books for initials, headings, and so on, the color should be pure: for example, red—the purest vermilion that can be had tending neither to orange nor to crimson; blue should not tend to either green or purple; and green should not lean toward blue or yellow.

Pen drawings for manuscripts that are to be filled in later with color are best done in watercolor and can be in a fairly pale shade of fawn, so that when the painting is complete the lines become practically invisible. Or they may be done in a darker tone and left to become part of the painting where a strong outline is needed to aid the design.

Ideally, drawings should be made as freely as the written letters, but most people need to pencil in one or two lines first. It is permissible to trace drawings onto paper or vellum, but too many rough drafts and preparatory work tend to produce a drawing lacking in vigor and movement. Any drawing is liable to become blunted around the edges when it is traced from the original onto the final surface, since, at the very least, it is traced from the original drawing once, then redrawn to transfer the traced drawing onto the page, and then very often traced over a third time with a pen or brush. In this way much of the freshness and sharpness of the original work can be lost and it becomes stiff.

Thus it is good to practice decorative pen work and drawings in the same way as the practice of lettering is done—in a free and direct manner. Start off with simple shapes and designs and gradually work up to original drawings or more elaborate decorations according to your talent and proficiency.

It is natural and indeed right for a beginner to learn the traditional way of writing and designing a book, but once the student has mastered the construction of the letter forms and the basic structure of the book page, there is no limit to the creative possibilities that open up.

Unless one is definitely making a copy of a historical manuscript a piece of calligraphy by a contemporary scribe should reflect the present age. It is better to produce a piece of work that is vigorous, free, and original,

even if the writing and decoration may not be up to standard in all respects, than to turn out a tidy, neat, lifeless, and overworked manuscript, the result of many rough drafts and earnest toil.

On looking at ancient manuscripts, one cannot help being impressed by some of the old scribes' cheerful disregard for set planning and their obvious enjoyment of their task and the freedom with which they attacked it. The student should also make this an aim: to plan roughly the pages of the book and then to write it boldly. In this way hand and eye will become accustomed to spacing the letters freely and judging the contrast of weight necessary between capitals and minuscules. This is better for practice than long sessions of writing alphabets over and over again. Practice by making a book, a broadside, a map, or anything you have the creative desire to achieve. It will not be perfect—none of us is—but it will be a unique and original interpretation of the subject matter.

There are far too many calligraphers at present, both amateur and professional, who turn out pieces of work that, while being well produced, are monotonously alike in approach and entirely lack any spontaneity or the stimulus of surprise. The beginner who makes a sincere study of good, plain, well-constructed letters arranged primarily in a simple, straightforward way, without being too influenced by others, will gradually acquire an individual style, instantly recognizable, which will be his or hers alone.

Fig. 102. Design for decorative capital letter by Marie Angel (from Two by Two by Toby Talbot, published by the Follett Publishing Company).

9. Binding of a Single-Section Manuscript Book

When a manuscript has been completed it should be protected by stitching up the pages to prevent damage or loss and placing them in an outer cover as further protection from handling.

To bind a book of several sections with boards and a leather covering requires special treatment and equipment. A calligrapher interested in bookbinding may find classes held in this subject by professional binders or at technical institutes and colleges. However, a single-section manuscript can be simply and easily bound by the calligrapher.

The materials required are scissors, heavy paper or thin card, a medium-size darning needle, and some thread. The thread should be fine for thin

papers and thicker for heavier papers. It is also best to have the thread match the color of the pages. The thin card or stout paper for the outer cover of the book may be of the color desired, or a colored-paper cover may be folded around it after the book has been stitched up in a similar way to a book jacket.

Assemble the leaves of the single section in their correct order. Cut a piece of the selected cover material so that when it is folded around the single section it projects beyond the head, tail, and fore edge of the book by approximately one-eighth of an inch. Allow for a certain amount of the overall width of the outer cover to be taken up by the spine of the book. This

105

stiff outer cover projecting beyond pages of book

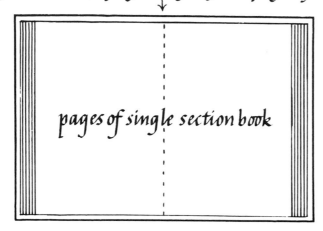

Fig. 103. Pages of single-section book laid on stiff outer cover.

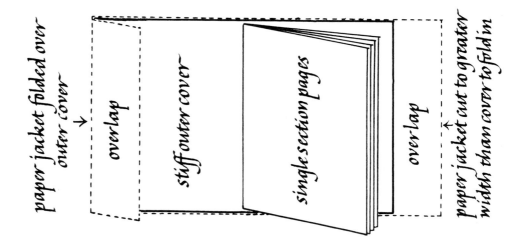

Fig. 104. Paper jacket may be folded around the outer cover if desired after the book has been stitched up.

will vary according to the thickness of the leaves of the single section. It is best to fold the outer cover around the book first so that this adjustment can be made before finally trimming to size.

If desired, a paper jacket can be folded over the stiff outer cover. Simply cut a piece of the chosen paper to overlap the overall width of the cover by an inch or more according to the size of the book. Fold the paper around the outer cover and turn in the overlap.

Take the assembled section and open it out at the central fold. Find the center of the length of the central fold and mark it in pencil. Divide the remaining upper and lower lengths into three separate parts and mark these points. There are now five points marked along the central fold.

Take up the complete section and tap the head of the pages lightly on a flat surface to align the leaves evenly at the head of the book. Keeping the alignment of the leaves correct, open the section at the center fold on a flat surface and place a heavy ruler on the verso page against the center fold. Holding the leaves of the section firmly in place by pressure on the ruler, pierce through the five points previously marked with a sharp needle or other fine instrument.

Now thread the needle with a length

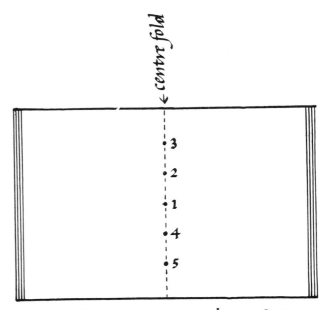

single section opened out flat

Fig. 105. Single section opened out at center and marked for stitching.

of thread twice as long as the spine of the book. Take the threaded needle through the central hole (1) and draw the thread through to the outside cover, leaving the end of the thread inside the book. Continue by taking the needle back into the book at point 2, out again through the cover at point 3. Now go back through 2, right across the central point (1), and bring the thread out again at 4. Return through 5, go out again at 4, and finally back through the central point (1). This

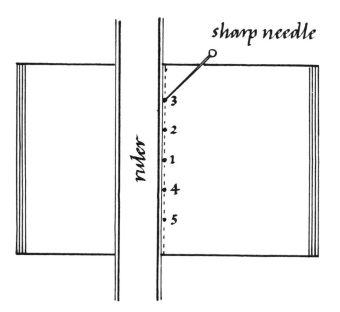

Fig. 106. Single section held firm by ruler as marks are pierced through by sharp needle.

stitches the whole section and the cover firmly together.

Make sure that the tension of the stitches is firm and not too tight. They should lie flat on the inner and outer sides of the book. When the tension is right, tie the two ends of the thread across the long central stitch to hold it down and to prevent the stitches from loosening. Cut off the two ends of the thread about half an inch above the knot.

Small manuscripts with very thin vellum leaves can be bound in a similar fashion, but larger books with heavier vellum pages should be bound by an experienced bookbinder. Never use adhesives on vellum and, if possible, avoid using them on paper. On vellum, wrinkling will occur almost inevi-

Fig. 107. Order and direction taken by needle and thread when sewing up the pages.

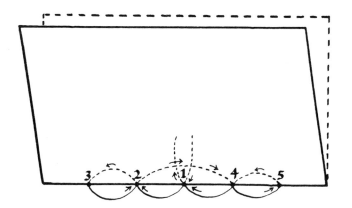

method of stitching through single section book

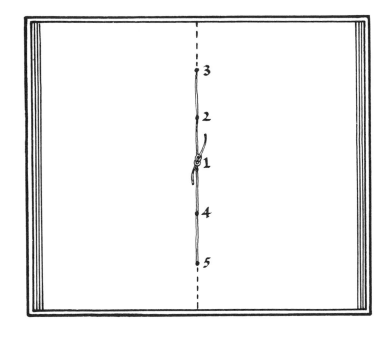

Figure 108. Center of section after stitching has been completed.

centre page showing finished stitches and knot

tably and some brands of adhesive mark the vellum ineradicably. On paper, warping is very likely to result unless the grain of the paper is correctly aligned. Wrinkling will also be present if the paper is allowed to become too damp. It is far better for the beginner to rely on dry methods of binding.

Covers may be decorated by using pen-made patterns, or the title of the book may be written directly onto its surface. The cover may be made from patterned paper—marbleized papers

make excellent covers. Another idea is to cover a book with Japanese papers; the kind covered with a veneer of wood should be strong enough to make an outer cover, and the softer type of silk paper would make a jacket cover. Ingres paper is made in many different and subtle colors, as are a number of other handmade papers that make excellent outer covers for books, with colors that either go with or contrast with the interior of the book.

Any manuscript that is not to be bound by a professional binder should

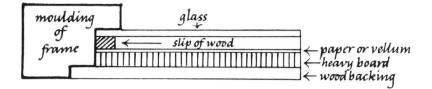

Fig. 109. Simple frame showing how various components fit together.

be stitched and suitably covered as soon as possible after completing the writing and decoration of the book. Even the simplest binding keeps the manuscript pages together, keeps the book clean, and prevents it from becoming crumpled or dog-eared.

Frames for broadsides or maps should be chosen carefully to enhance the work. Calligraphy does not look good in too large or heavy a frame. Moldings in neutral colors lightened with a touch of gilt are a good choice. Narrow gilded or silver frames can sometimes be very effective. If work is being framed for exhibition take special care that the color of the frame is not too obtrusive, for this would make it difficult to hang with other works. Frames should always be well finished and backed efficiently to exclude dust.

The choice of a suitable frame for each piece of work is the responsibility of the scribe. It is impossible to give hard and fast rules on this subject because every piece of work must be considered separately. The best guide on this matter for the beginner is a good picture framer who might be willing to give advice based on experience.

Generally nowadays broadsides and maps are framed without a mount, leaving the molding itself to define the margins. However, a slip should be placed between the glass and the piece of work so that the surface does not come into contact with the glass; otherwise any slight moisture or dampness will cause colors and nonwaterproof inks to smudge and paper, unless stretched, to wrinkle.

Vellum of small size—not above eight inches square—may be framed unmounted in the same way as paper with a slip between the glass and the vellum so that the vellum does not touch the surface of the glass. Vellum,

however small, should be backed with a fairly heavy board to prevent wrinkling.

If a larger piece of vellum is used for a broadside or a map it must be stretched to prevent wrinkling from atmospheric conditions after framing. Stretching of vellum requires a great deal of experience. It should be done by a professional picture framer or other skilled person to be successful. It is possible to have vellum stretched before the work is begun, but it is more difficult to write on a piece of vellum stretched on a stout board, so stretching should be done preferably after the work is finished.

The binding and framing of finished manuscripts, broadsides, and maps should always be regarded as an important part of the work. But the student should bear in mind that however well the original piece of calligraphy has been carried out, a slipshod binding with a poorly designed cover, or a frame with an ugly molding of an unfortunate color that detracts from the calligraphy, must degrade the whole work to a certain degree. This is an important point to remember when submitting work to an exhibition or for competition, since poorly presented work may be rejected by the organizers.

10. Toward Advanced Studies

This chapter is for all those who wish to advance further in their study of calligraphy than this book takes them. Learning from books with examples and from writing cards is bound to be limiting to anyone working on his or her own, since it is difficult to make that critical assessment of one's own work that is so necessary for progress.

To learn the writing of more complicated hands, the making of compound letters called *versals*, the cutting of quills, and that ultimate aim of all scribes, the art of raised gilding, one needs, if possible, practical demonstrations and guidance by a qualified teacher. This means lessons, either privately or in corporate classes such as workshop seminars, and the attendance of any lectures in one's vicinity.

Fortunately, the greatly increased interest in calligraphy in recent years has led to the formation of a number of societies, guilds, and workshops in America, and the very best thing that anyone interested in advanced calligraphy can do is to join a group in his or her own area. These groups are formed by enthusiasts who arrange meetings attended by fellow calligraphers, hold classes and competitions for members, and often have famous calligraphers visiting to give a lecture or series of lectures on the craft. News about materials such as pens, paper,

ink, colors, and so on is passed around, and more advanced members are always ready to help the beginner.

There will be many people, however, who have no such group in the area in which they live. For these some colleges and universities have special summer courses that enthusiasts might attend as part of their summer vacation. The Calligraphy Workshop in New York City has year-round courses on italic handwriting, lettering, and illumination. Another possibility is to join the nearest group as a corresponding member and share the information printed in newsletters, which nearly all societies send out to their members. They are also likely to hold competitions and small exhibitions within their society, which should help a scribe gauge the standard of his or her own work.

If none of these things is possible, there is usually a public library within reach. There is a short bibliography at the end of this book, and quite a few of the books can be obtained through Pentalic Corporation or Museum Books, but a good library would almost certainly have a much wider variety of specialized books on the subject, many of which are now out of print. Some of the great libraries have magnificent collections of original manuscripts, such as the Pierpont Morgan Library in

New York City, the Newberry Library in Chicago, and the Walters Art Gallery and the Peabody Institute Library in Baltimore.

It is only by studying calligraphy, both historical and contemporary, that one can hope to judge one's own performance, so never miss the chance to see an exhibition, listen to a lecture, or follow a demonstration of the craft. It is only by acquiring knowledge of the subject that one can hope to advance and make further progress.

This is particularly true of raised gilding, which is still carried out in the traditional way used by the scribes who produced the magnificent illuminated books of centuries past. One of the finest gilders of today is Donald Jackson, who not only gilds with apparent ease but uses it in a most imaginative and original manner. If you are lucky enough to see one of his demonstrations you will be very fortunate.

Raised gilding is most difficult to learn without personal tuition or demonstration; the making of the size used to execute the raised letter form is itself a complicated and precise process. However, if you are brave enough to try, you will find detailed instructions in Edward Johnston's book *Writing and Illuminating and Lettering,* and a chapter by Irene Base devoted to the subject in C. M. Lamb (ed.), *The Calligrapher's*

Handbook, giving clear and concise details. Materials for gilding are obtainable in the United States and suppliers are listed at the end of this book.

A much easier way for beginners to brighten manuscripts is to use mat or shell gold. This may be bought ready for use. It is comparatively expensive to buy, as it is not "gold" paint but pure gold dust in cake form. It is moistened with distilled water and applied with a brush. It can be used with a quill, but this is more difficult because it tends to clog. Whatever instrument is chosen, it should be completely clean and should not be used for other purposes. Always rinse the brush or pen in distilled water kept in a special receptacle that has an airtight lid. When the brush or pen is washed the gold grains sink to the bottom of the receptacle and can be collected and used again.

Shell gold has to be of just the right consistency, so that as it dries out the grains lie evenly on the surface—too much water will mean that when it dries out the gold dust will be too widely spaced to give an effective appearance. So make sure enough gold is suspended in the medium before transferring it by brush or pen to the page. Using shell gold with very little water makes it stiff and unmanageable and it dries with a rough surface.

I was once told by an old craftsman that to use shell gold skillfully for flat areas I should think of the sand left smooth and hard as the tide drains away. The mixture must be wet enough to handle easily but contain enough grains of gold to lay an even cover over the whole surface as the medium dries out.

The best way to use shell gold is for small spots or fine lines. In historic manuscripts it was applied skillfully and with discretion. There should be just enough gold used to give a glint to the page; too much results in a vulgar effect. Shell gold is very attractive laid on over color. Small spots may be used for the centers of floral decorations, in diaper patterns as stars or crosses, or as small areas of flat color such as squares or lozenges. When it is quite dry it may be burnished, but it probably looks best as mat gold. It is not suitable for large decorative initials or formal work, which will always require raised gilding. But it can be used most effectively in conjunction with raised gilding, the contrast between them being very pleasant.

Neither calligraphy nor gilding are arts which may be mastered quickly, both requiring a long apprenticeship from the student. However devoted their practice may be, most will never reach the highest peaks of calligraphic

skill shown by such famous scribes as Edward Johnston and Rudolf Koch in Europe, or by contemporary American calligraphers Lloyd Reynolds, Arnold Banks, and the late Byron J. Macdonald. This fact should deter none of us. A sound understanding of the basic prin- ciples underlying the construction of letter forms, and their use in a simple well-proportioned design on the page, must create beauty and give satisfaction not only to the student callig- rapher but to all others who view their handiwork.

FECIT 1976

Appendixes

I am greatly indebted for the following lists to Judith Mieger and the American pages of the S.S.I. Newsletter and to the Pentalic Corporation, and I trust that the information given is still correct. I am sure that there are many more classes and courses being given in calligraphy than those few mentioned here, so make inquiries in your local area at colleges, universities, libraries, or anywhere else where information about tuition can be obtained.

SOCIETIES DEVOTED TO CALLIGRAPHY AND BOOK ARTS

CALLIGRAPHERS GUILD, P.O. Box 304, Ashland, Oregon 97520.

CALLIGRAPHERS GUILD, Washington, D.C., c/o 3105 Northwood Road, Fairfax, Virginia 22030.

CHICAGO CALLIGRAPHY COLLECTIVE, 834 Chalmers Place, Chicago, Illinois 60614.

COLLEAGUES OF CALLIGRAPHY, 1605 Summit Avenue, St. Paul, Minnesota 55105.

FRIENDS OF CALLIGRAPHY, 1804 Sonoma, Berkeley, California 94797. Newsletters, workshops, lectures.

GUILD OF BOOK ARTS, Route 2, Box 763, Carmel, California 93921.

GUILD OF BOOKWORKERS, 1059 Third Avenue, New York, New York 10021. Journal with pictures and supply lists, etc.

NEW ORLEANS CALLIGRAPHERS ASSOCIATION, 6161 Marquette Place, New Orleans, Louisiana 70118.

THE SOCIETY FOR CALLIGRAPHY, 1817 Selby Avenue, Apt. 8, Los Angeles, California 90025. Newsletter "Calligraphy Ink."

SOCIETY FOR ITALIC HANDWRITING (S.I.H.), Editor—Dr. A. S. Osley, The Glade, Brook Road, Wormley, Godalming, Surrey, England. Quarterly journal.

SOCIETY FOR ITALIC HANDWRITING (S.I.H.), Western American Branch, 6800 S.E. 32nd Street, Portland, Oregon 97202. Quarterly journal.

SOCIETY OF SCRIBES, P.O. Box 933, New York, New York 10022. Organizes lectures, classes, demonstrations, etc.

SOCIETY OF SCRIBES AND ILLUMINATORS (S.S.I.), c/o The Federation of British Craft Societies, Bristol House, 80A Southampton Row, London W.C.1. Quarterly newsletter, containing much information, includes a page on American activities.

WORKSHOPS, CLASSES, ETC.

CALLIGRAPHER'S WORKSHOP, sponsored by the Pentalic Corporation, 80 Fifth Avenue, New York, New York 10011. Calligraphy classes for beginners through advanced. Inquiries to Pentalic Corporation.

GEORGIANNA GREENWOOD. University of California. Calligraphy classes.

GUILD OF BOOK ARTS. Carmel, California. Classes in typography and bookbinding as well as calligraphy, illumination, etc.

DONALD JACKSON. Probably the best known of all British calligraphers practicing today and equally well known in the United States for his frequent tours of lectures and workshops. Appointed Distinguished Visiting Professor at the California State University for the year 1976–77.

RUTH JOSSLIN. School of Arts and Crafts, Portland, Oregon. Calligraphy classes.

SISTER LEONARDA LONGEN. St. Mary's College, Yankton, South Dakota. Calligraphy classes.

SHEILA WATERS. 20740 Warfield Court, Gaithersburg, Maryland 20760. Well-known calligrapher in Britain before making her home in America. President of the Calligraphers Guild, Washington, D.C. Holds calligraphy classes.

SUPPLIERS OF CALLIGRAPHIC MATERIALS IN THE UNITED STATES

CALLIS CALLIGRAPHIC SUPPLY, P.O. Box 1787, Monterey, California 93940. Calligraphic supplies by mail order.

BRADLEY ELFMAN, 5418 Magazine Street (at Jefferson Ave.), New Orleans, Louisiana 70121. General calligraphic supplies.

FINE ART MATERIALS, INC., 530 LaGuardia Place, New York, New York 10012. All types of papers, etc.

SAM FLAX, 25 East 28th Street, New York, New York 10001. 55 East 55th Street, New York, New York 10022. Handmade papers.

GREY OWL, 150/02 Beaver Road, Jamaica, New York 11433. Quills.

CHAS. MEDINNIS, 4747 El Caballero Drive, Tarzana, California 91356. General calligraphic supplies.

KATHLEEN TAUGHER MURRAY, 123 Mar Vista Drive, Monterey, California 93940. General calligraphic supplies.

PAPERMAKE, 433 M, Fairlawn East, Covington, Virginia 24426. Handmade and other papers.

PENTALIC CORPORATION, 132 West 22nd Street, New York, New York 10011. Nearly all materials mentioned in this book can be obtained from the above, including a great many books on the subject. Sponsors the Calligraphy Workshop which is used as a center for classes by American and other visiting lecturers.

SCRIPTORIUM BENEDICTINE, 410 S. Michigan Boulevard, Chicago, Illinois 60605. Pens, quills, stick ink, agate, and hematite burnishers, etc., gilding materials.

SPECIAL PAPERS INC., West Redding, Connecticut 06896. Variety of handmade and other papers including French imported papers.

BETTY SWEREN, Caveswood Lane, Owing Mills, Maryland 21117. Paper, pens, and other materials.

JOSEPH TORCH, 29 West 15th Street, New York, New York 10011. Artist colors, designers' gouache, etc.

WORLD WIDE HERBS, 11 St. Catherine Street, East, Montreal, 129, Canada. Gum sandarac, gum ammoniac, and gum arabic.

SUPPLIERS OF MATERIALS IN ENGLAND

H. BAND AND CO. LTD., Brent Way, High Street, Brentford, Middlesex, TW8 8ET. Vellum of all types and parchment.

BRITISH PENS LTD., Bearwood Road, Smethwick, Worley, Worcestershire. Higgins Ink.

L. CORNELISSEN AND SON, 22 Great Queen Street, London, W.C.2. All materials for illuminating.

DRYAD, Dept. L. Northgates, Leicester, LE1 4QR. Pens, writing cards, paints.

FALKINERS FINE PAPERS LTD., 4 Mart Street, London, WC2E 8DE. Large variety of papers for every calligraphic purpose. Also materials for calligraphy and gilding.

J. BARCHAM GREEN, Springfield Mill, Maidstone, Kent. Superior handmade papers.

A. LUDWIG AND SONS LTD., 71, Parkway, London, NW1 7QJ. Ingres papers.

PAPERCHASE, 216 Tottenham Court Road, London. All sorts of paper. "Ivoryboard" suitable for writing on for greeting cards, etc.

RUSSELL BOOKCRAFTS, Hitchin, Hertfordshire. Bookbinding materials, Ingres and marbled Cockerell papers.

G. M. WHILEY LTD., Stonefield Close, Stonefield Way, Victoria Road, Ruislip, Middlesex, HA4 OLG. Gold leaf, shell gold.

WINSOR & NEWTON, Wealdstone, Middlesex. Artist colors, brushes, etc.

SOME PUBLICATIONS ABOUT CALLIGRAPHY

Calligrafree. 43 Ankara Avenue, Brookeville, Ohio 45309.

Calligraphy Review. New Orleans Center for the Creative Arts, 6048 Perrier Street, New Orleans, Louisiana 70115.

Italic News. Italimuse, 29 Ridgeway, Greenwich, Connecticut 06830.

BIBLIOGRAPHY

Calligraphy. The Golden Age and Its Modern Revival. Portland, Oreg.: Portland Art Association, 1958.

Camp, Ann. *Pen Lettering*. Dryad Press, 1964.

Catich, Edward M. *Reed, Pen and Brush Alphabets for Writing and Lettering*. St. Ambrose College, Davenport, Iowa: Catfish Press, 1968.

Child, Heather. *Calligraphy Today*. Revised and updated edition. Studio Vista, 1976.

Fairbank, Alfred. *A Handwriting Manual*. London: Faber and Faber, 1961.

———. *The Story of Handwriting*. London: Faber and Faber, 1971.

Johnston, Edward. *A Book of Sample Scripts*. London: HMSO, 1966.

———. *Formal Penmanship*. Edited by Heather Child. Lund Humphries, 1971.

———. *Writing and Illuminating and Lettering*. Pitman.

Lamb, C. M., ed. *The Calligrapher's Handbook*. London: Faber and Faber.

Macdonald, Byron. *The Art of Lettering with the Broad Pen*. Pentalic, 1973.

Miner, Dorothy E.; Carlson, Victor I.; and Filby, P. W. *Catalogue of the 1965 Calligraphy Exhibition in Baltimore*. Baltimore, Maryland: Walters Art Gallery, 1965.

Mitchell, Sabrina. *Medieval Manuscript Painting*. London: Weidenfeld & Nicholson, 1965.

Modern Lettering and Calligraphy. Studio Publications, 1959.

Reynolds, Lloyd R. *Italic Calligraphy and Handwriting*. Pentalic, 1969.

Standard, Paul. *Calligraphy's Flowering, Decay and Restoration with Hints for Its Wider Use Today*. Chicago: Society of Typographic Arts, 1947.

Tschichold, Jan. *An Illustrated History of Writing and Lettering*. Zwemmer, 1946.

Wellington, Irene. *Irene Wellington Copybooks*. London: Heinemann.